# stitching
# the textured
# surface

LYNDA MONK & CAROL MCFEE

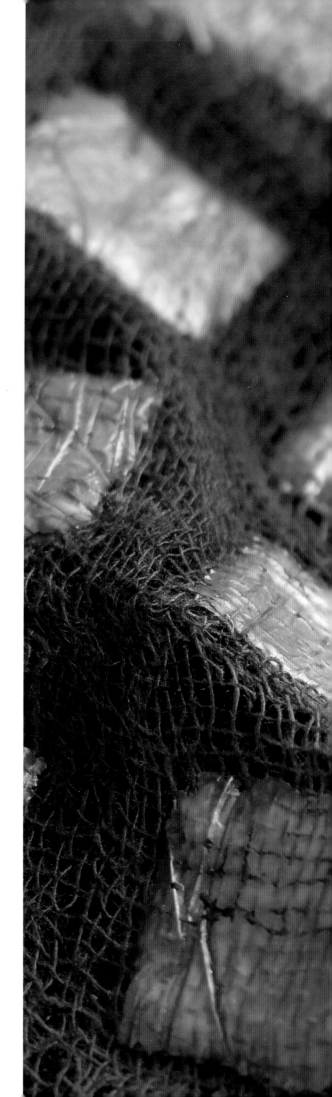

2

# Contents

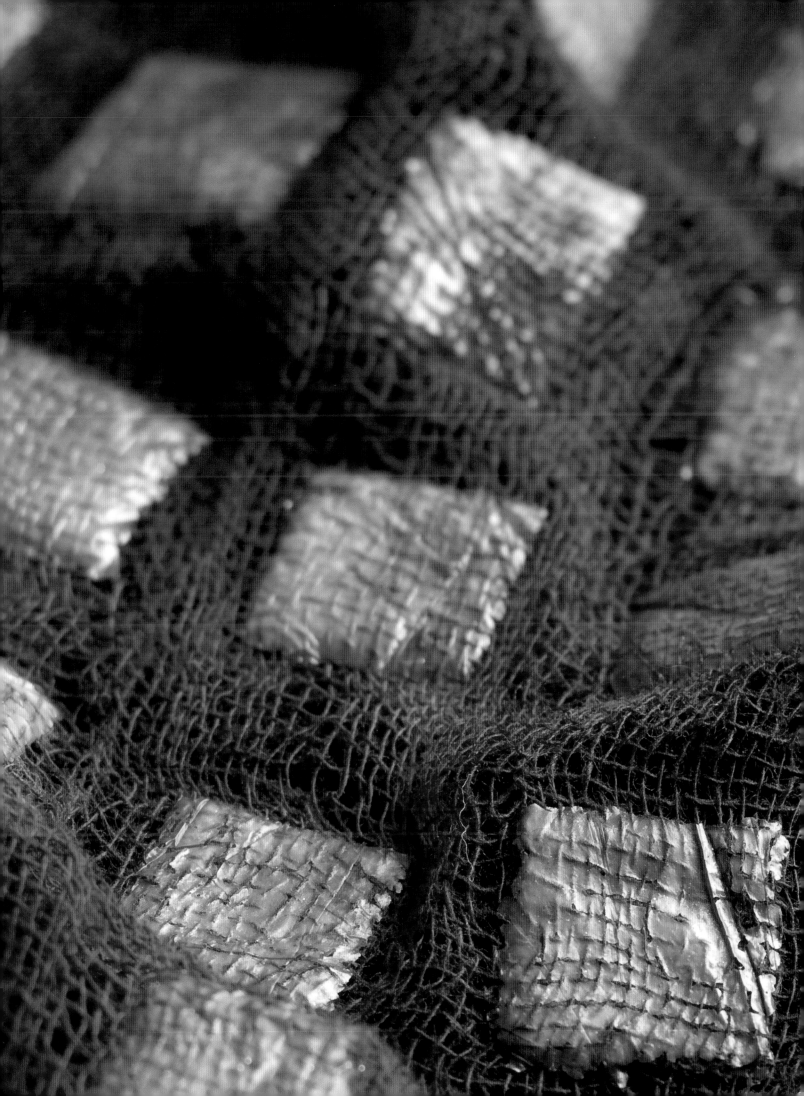

# Introduction

Acrylic gesso and molding paste, produced for acrylic artists, have now become very useful additions to the textile artist's workbox. We all love trying out new materials and techniques and it's such fun to experiment and create.

**The aims of this book are:**

* to help you explore some of the many different effects you can achieve by using gesso or molding paste in your textile work
* to extend the use of these materials and introduce innovative techniques to create exciting surfaces with such materials as kunin felt, Tyvek and Lutradur
* to introduce you to new colour media and re-invent the more traditional ones
* to help you use these textured surfaces in your own work, whether stitch (we have re-defined the concept of quilt), mixed media textiles, paper arts, books, three-dimensional work or smaller items such as artists' trading cards or postcards.

Most of the techniques and finished pieces shown in this book can be created using either gesso or molding paste and we certainly encourage you to try both products; you may prefer the results of one over the other. You will probably have used materials such as Lutradur and Tyvek with a heat tool and we shall be looking at this process. However, we're always amazed at the effects that can be achieved on these fabrics without the use of heat. They have some wonderful properties to explore.

Our best advice to you is to 'try it and see' – you will be delighted with the unexpected outcome when using different combinations of materials and products.

Reversible vessels created using a base fabric of zapped kunin felt.

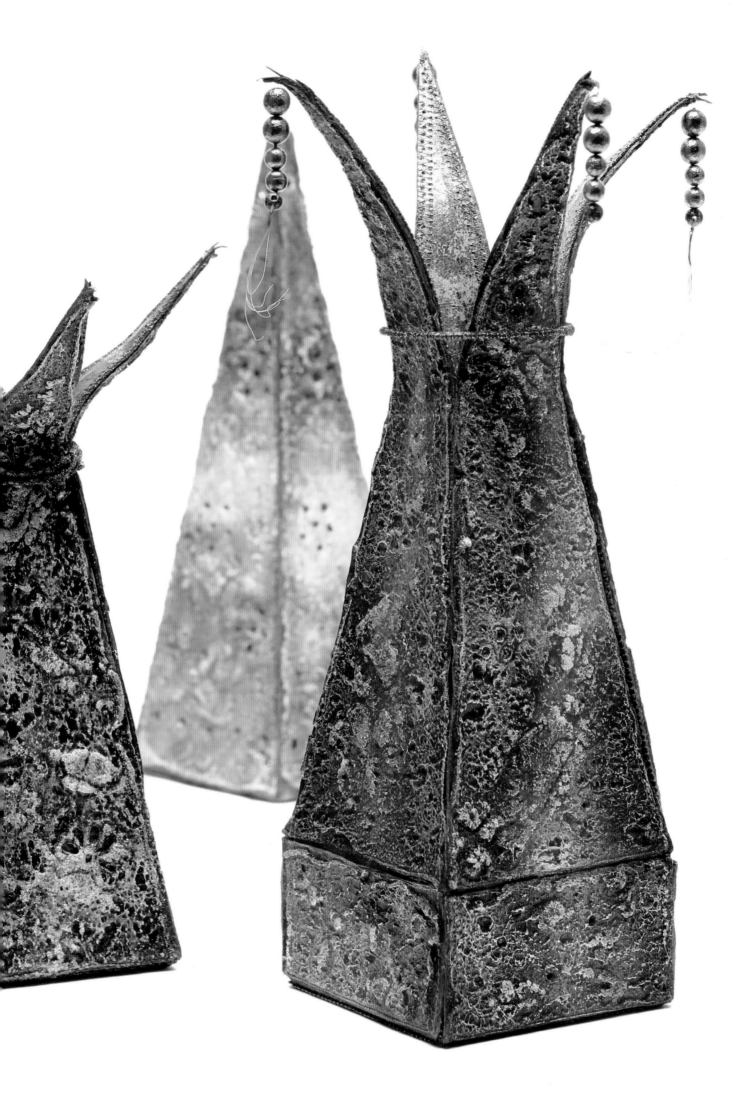

# SECTION 1

# Textured surfaces

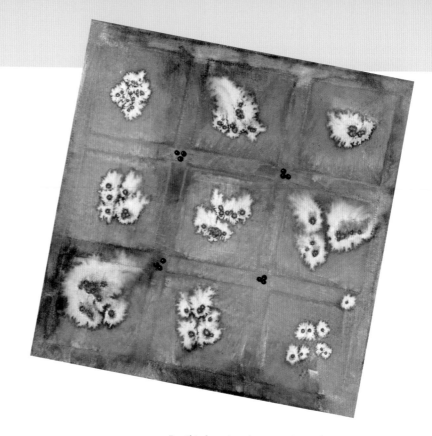

In this section we'll be looking at two main products: gesso and molding paste. Both should be easy to find in local art shops or on the internet.

## Using gesso and molding paste

Mixed media work is a delight and there are so many options for using both gesso and molding paste. In this section, we'll be looking at using them with stencils, stamps and acetate. We'll also explore the combination of these materials with fabric and stitch.

For this hanging, heavy cotton calico has been quilted into squares. Gesso has been allowed to dry thoroughly before being coated with ink and just a few grains of coarse sea salt have been placed in each square.

### GESSO

There are many different brands of acrylic gesso to choose from and each brand varies slightly in consistency, some being reasonably thick and some quite runny. While some techniques require a heavy body texture (such as that shown left), others benefit from a thinner mix.

If your preferred brand is too thick for the technique you wish to try, use water, no more than 10%, to thin it down. On the other hand, if you need to thicken your gesso, use a small amount of whiting (chalk). This is readily available in powdered form, at a very reasonable cost, from a good art supply store. Add a small amount at a time, stirring constantly, until the gesso reaches the thickness you require.

You could also use builders' plaster, Polyfilla or plaster of paris (molding powder) to thicken the gesso. However, add these very sparingly and only make a little at a time as these powders may set the gesso if it is left for too long. Also, be aware that if you add too much of any of these powders, the resulting surface will be rock-hard and crack very easily.

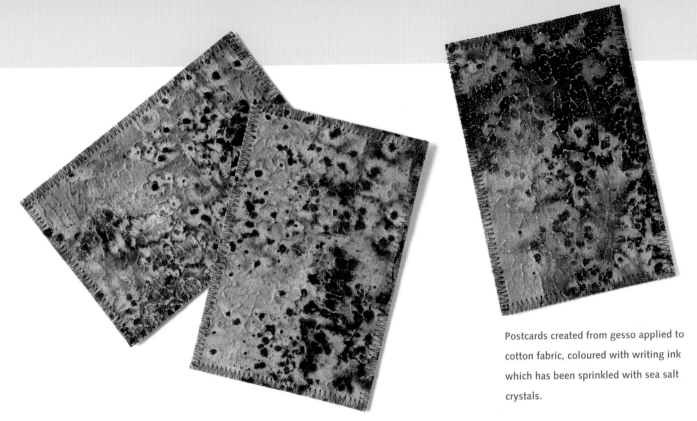

Postcards created from gesso applied to cotton fabric, coloured with writing ink which has been sprinkled with sea salt crystals.

## HOME-MADE GESSO RECIPE

As an alternative to purchased acrylic gesso, you can produce your own mix, which will work in much the same way, using household emulsion (latex paint) and whiting.

You will need:

- household matt emulsion
- whiting
- jar or pot with a screw lid
- mixing bowl, dessert spoon and a fork for mixing
- sieve.

Take two dessert spoonfuls of emulsion and place in the bowl. Then add a heaped dessert spoonful of sieved whiting powder. Mix with a fork until all the powder has dispersed and you are left with a smooth consistency. Adding a small amount of PVA glue will give you a slightly more flexible mix and make it easier to sew. The quantities here are just a guide – they don't have to be exact.

The finished mix will make quite a thin gesso. You can add more whiting if necessary, a little at a time, until you have the consistency you desire but, as mentioned previously, if too much whiting is added, this will result in cracking once the mixture has dried after application, although this can be used to advantage.

Transfer the mixture to a jar or pot with a screw lid to keep it workable. It's a good idea to make small samples and keep notes on the type of gesso, how you applied it and any other methods used. This will enable you to replicate the effect at a later date. Leave the samples loose so that you can feel how the fabric handles and decide whether or not it will be suitable for the project you have in mind.

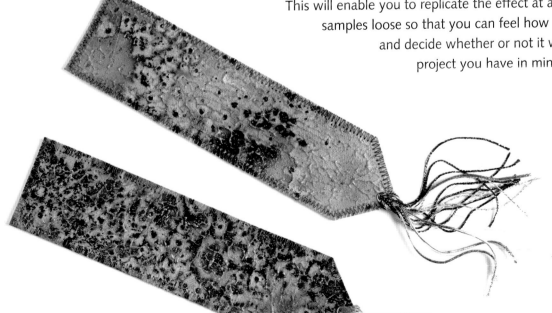

Bookmarks, postcards and ATCs are an ideal way of using samples and experimental pieces of work.

Gesso also has the advantage of covering lots of different surfaces, a good opportunity to use those scrap fabrics and threads that we all tend to hoard.

All tools and equipment used should be thoroughly washed directly after use.

Molding paste and gesso will work in much the same way for the following techniques of application and colouring. However, molding paste remains far more flexible than gesso and is also easier to use for stamping and stencilling because of its consistency. We suggest you try both products to compare the results before deciding which one to use for your intended piece.

Scrap cotton fabrics, stitched into shape and coated with gesso. These surfaces could be further enhanced with the addition of colour.

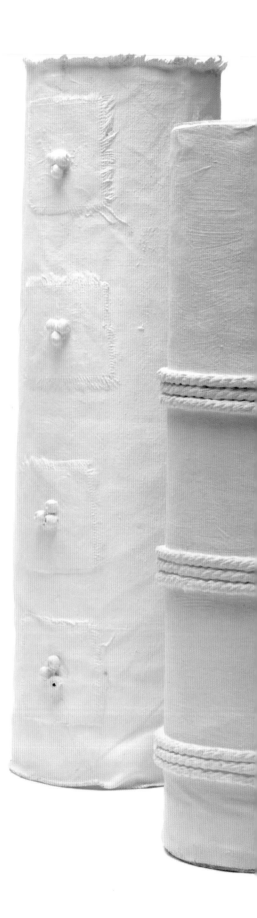

## MOLDING PASTE

Many different types of molding paste are available: Extra Heavy Gel/molding paste, Fibre Paste, Hard, Regular and Light molding paste, and Coarse molding paste. Golden's Regular molding paste has been used throughout this book for the samples and finished pieces. If possible, experiment with as many varieties as you can. You will get slightly different results with each but you may find there is a particular one that you prefer to work with.

By applying molding paste to fabrics, a new dimension can be added to textile work. Our samples show how it can be applied to a variety of surfaces and coloured with many different mediums.

As the paste is a water-based product, tools can be cleaned easily as long as they are not allowed to dry. Keep a small dish of water next to the work area and leave tools to soak until they can be rinsed thoroughly.

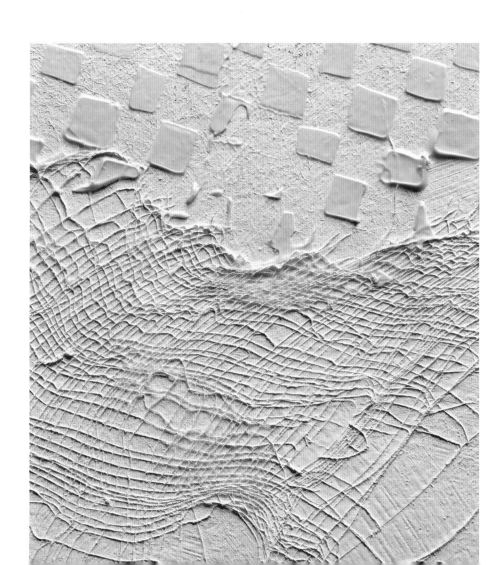

# Application

Molding paste and gesso can be applied to many different fabrics and fibres, such as calico, pelmet Vilene, box canvas, nappy (diaper) liners or agricultural fleece, Lutradur, Evalon, scrim, organza and Tyvek. Molding paste can also be used effectively on acetate, copper shim and foiled surfaces. These mediums can be brushed on to create texture, applied through stencils or stippled over masks.

Or you can:

- use bold wooden or rubber stamps pressed into the surface
- press sequin waste or plastic lace into the wet surface or stencil through it
- use corks and wooden shapes to create a design
- use a wide-tooth comb to make marks or draw into the surface with a kebab stick
- stipple the surface to create texture.

These are just a few suggestions on how versatile the products can be.

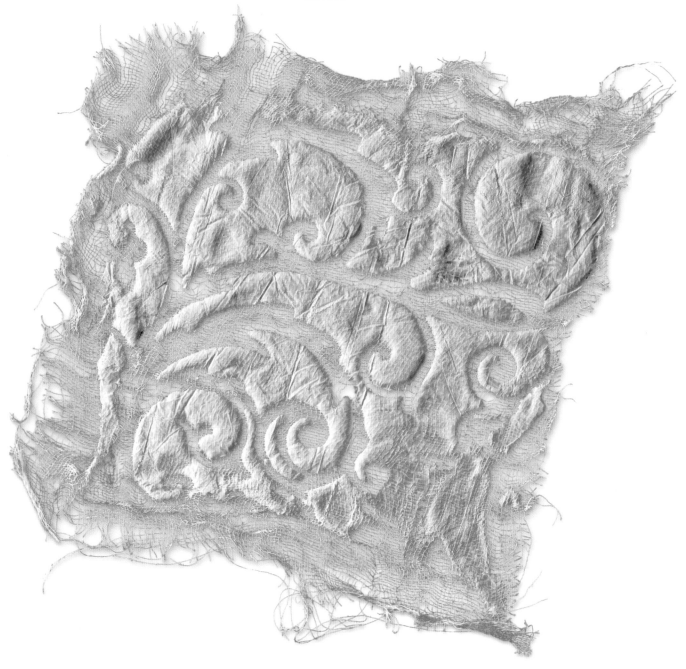

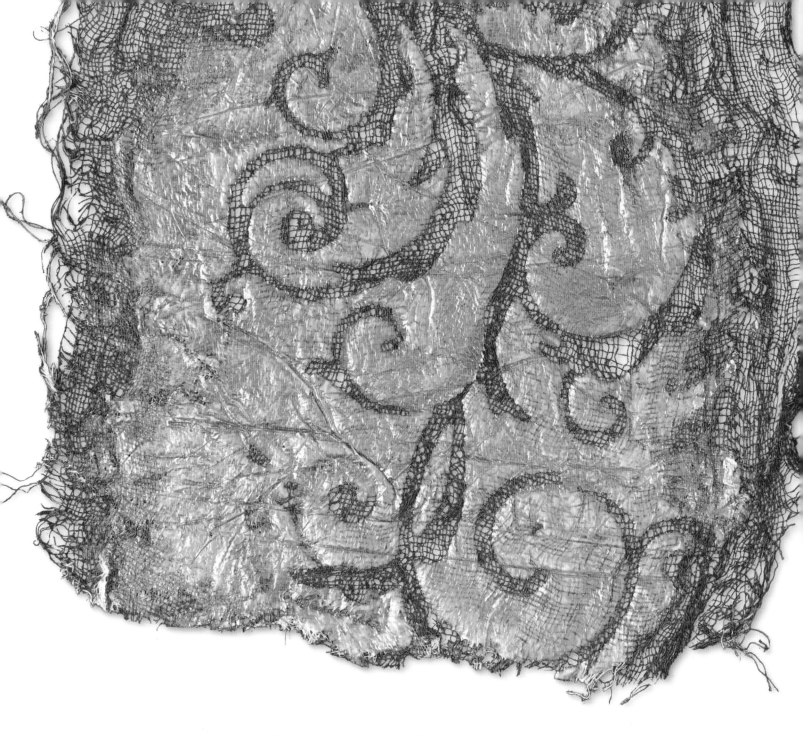

## STENCILS AND MASKS

A huge variety of stencils is available in craft and scrapbook stores. Alternatively, you can make your own designs using cardboard, such as from breakfast cereal boxes. The coating on the front of the card ensures the stencils can be washed and re-used a number of times. If you need a longer-lasting stencil, coat both sides with PVA glue and allow to dry thoroughly before use.

Masks made from thick acetate allow an intricate design to be applied to the surface, creating a negative effect. It is also available at scrapbook stores. Thermofax screens will work quite successfully with gesso but do make sure you rinse the screen thoroughly immediately after use.

## ACETATE

Molding paste can be used to great effect on acetate sheets. Apply the molding paste through a stencil and, while the stencil is still in position, spray inks or colour-wash dyes over the surface. Carefully lift the stencil away and allow the molding paste to dry.

Turn the piece face down and apply a double-sided adhesive sheet to the back of the acetate. Peel away the protective paper and add loose metal leaf or metal flakes to the adhesive surface. Brush off any excess leaf and turn the acetate sheet right side up. Stitch to a base fabric, either as a sample on its own or integrated into a project.

## LACE

Cotton lace can be used as a stencil to apply the molding paste. Look carefully at the pattern of the lace as it is the design of the negative spaces that will be created by the paste.

ABOVE: Cotton lace was used as a stencil to apply the molding paste to a box canvas.

## CALICO WITH SCRIM AND MOLDING PASTE

Prime the calico (muslin) with gesso or white household emulsion (latex paint). It is important to prime the fabric as this will prevent the coloured layers being absorbed into the fabric base and helps the molding paste adhere to the surface.

Place small scraps of scrim (cheesecloth) onto the calico while the base layer is wet and press into place. Dab the surface of the scrim with the paintbrush to secure it to the base fabric.

Apply the molding paste through the mask, overlapping the scrim in some places, and allow to dry thoroughly before adding colour.

Try using pelmet Vilene or a box canvas for this technique. A stencil can also be used to achieve a similar effect.

## TEXTURE AND STITCH

To create a textured surface, the molding paste can also be applied with an old paintbrush or spatula. Apply it thickly and allow the uneven surface to dry and so create the texture.

Hand stitch can be added to the surface before applying the molding paste. Use a thick thread or thin string to create depth. Beads can also be added to the thickly applied molding paste. Once dry, cover with white paint.

## NAPPY (DIAPER) LINER AND MOLDING PASTE

When applying the paste through a stencil, the nappy liner can easily lift and cause the paste to seep underneath the stencil, smudging the design. To overcome this, place the nappy liner on a background fabric such as velvet before applying the paste. This will create a more stable surface for the stencilled design. Leave in place until completely dry, then stitch around the stencil and the excess nappy liner.

Note: If you cannot obtain nappy liners, the fine agricultural fleece (available from garden centres and used to protect plants from frost) is a good substitute.

TOP: Molding paste brushed onto base fabric with beads added for texture.

LEFT: Nappy liner and molding paste.

The book cover shown right uses a nappy (diaper) liner which was attached to velvet before stencilling. Markal (Shiva) Paintstiks in copper and turquoise were rubbed over the surface of the nappy liner and blended together. It was left overnight to give the Paintstik sufficient time to cure.

The piece was distressed, using a heat tool, like this.

- Place the sample onto a heat-resistant sheet and carefully start to burn away the nappy liner.

- Hold the heat tool a few inches away from the surface as it burns very quickly and you don't want the nappy liner to disintegrate completely.

The weight of the velvet makes it perfect to create a simple sketchbook cover. The velvet was stitched to painted pelmet Vilene and then one signature of watercolour paper was attached using a simple pamphlet stitch.

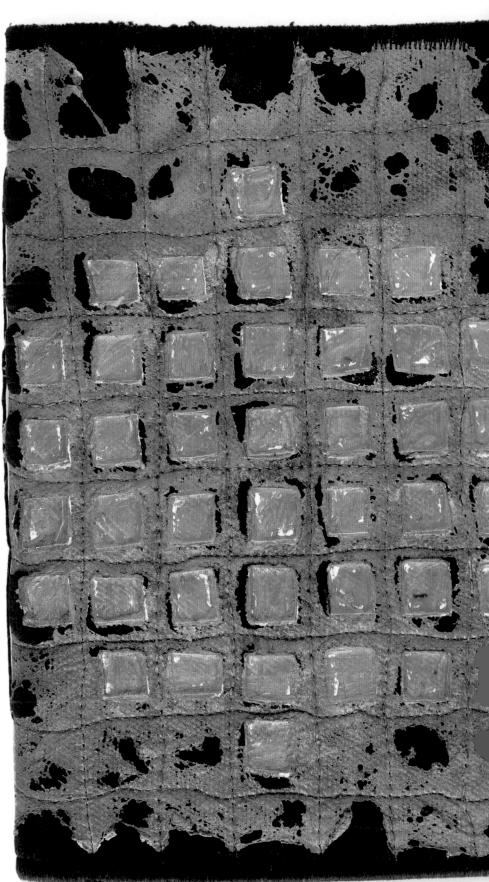

RIGHT: Book cover showing nappy liner coloured with Markal (Shiva) Paintstiks and distressed with a heat tool.

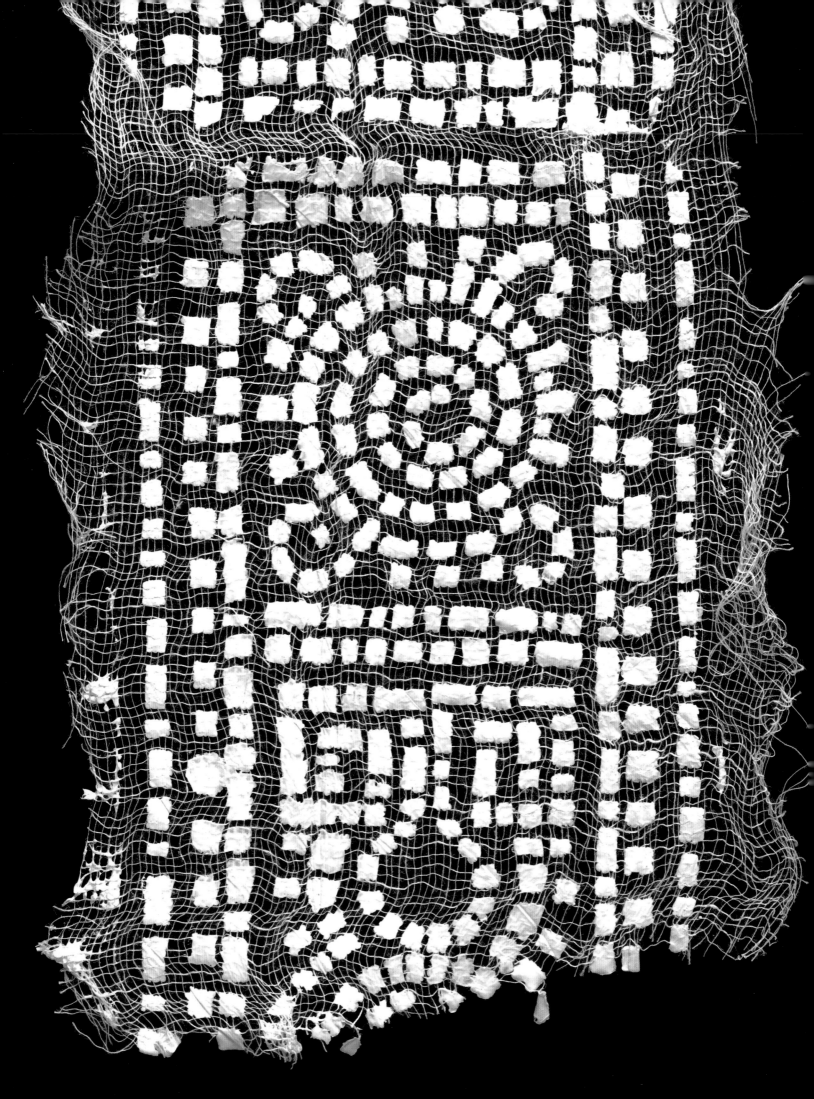

In the piece shown on the left, the edges of the scrim were frayed before applying the molding paste. A sheet of plastic was laid on the work surface as this made it easier to remove the scrim once the paste was dry. A stencil was placed in position on the surface of the scrim and molding paste applied using a spatula or old credit card. The stencil was lifted carefully while holding the scrim down firmly to prevent it from moving.

When this layer was completely dry, the stencil could be repositioned and more paste added until the desired effect was achieved.

When it was dry the piece was painted using a wet brush with Golden fluid acrylics, Transparent Red Oxide, Quinacridone Nickel Azo Gold and Phthalo Turquoise.

The stencilled scrim could be pulled apart to create slips to attach to a base fabric. Integrate them into the surface by machine or hand stitch, or apply molding paste over the edges.

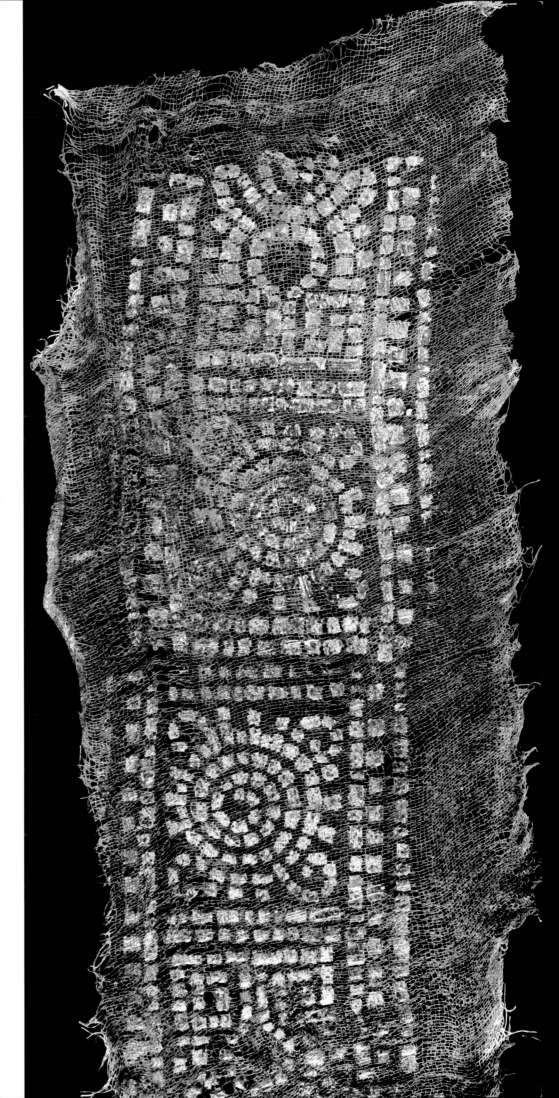

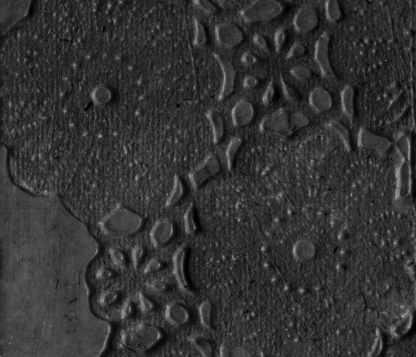

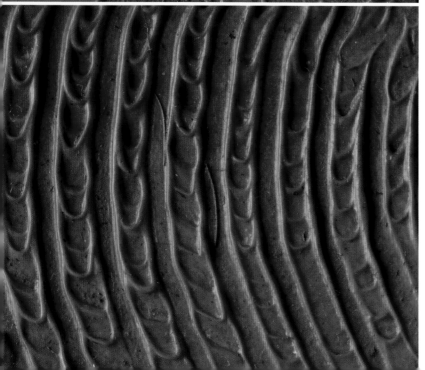

## FOUND OBJECTS

On the left you can see the effect of using a collection of found objects to add texture to the molding paste.

Top to bottom: Pressing sequin waste into wet paste, pressing plastic lace into the wet paste, using a wide-tooth comb to stipple the surface.

Take time to create a large selection of samples so that, once you are ready to add colour, you can enjoy the process without waiting for the molding paste or gesso samples to dry. These samples will be great for making artists' trading cards or postcards.

In the piece shown right, the calico base was painted with Golden's paynes grey fluid acrylic and, while still wet, Perfect Pearls pigment powders were sprinkled over the surface. The excess powder was gently tapped off and left to dry overnight as the base coat of paint takes longer than usual to dry.

# Colouring

Various colouring agents can be added to gesso or molding paste before use, the best choice being acrylic paint (adding around 10% paint is usually sufficient). Bear in mind that all additives will appear much lighter in colour than with normal use. Each product will take colour on the wet surface slightly differently as gesso is far more absorbent than molding paste.

To apply colour to the surface of the molding paste while it is still wet, the best results are obtained by spraying inks and dyes such as Adirondack colourwash inks, Moon Glow sprays, cold water dyes, writing ink, calligraphy ink and Brusho powders. The dyes and Brusho powders can be made up ready to use and kept indefinitely in small spray bottles.

Once the molding paste or gesso is completely dry, any of the above can be used. Also try acrylic paint, pigment powders, ink pads, chalk pastels, oil pastels, Markal (Shiva) Paintstiks, Koh-i-Noor watercolour dye, gilding cream, gilding powders and Interference paints. The samples in this section were all created using molding paste, although in most cases you could achieve the same results using gesso.

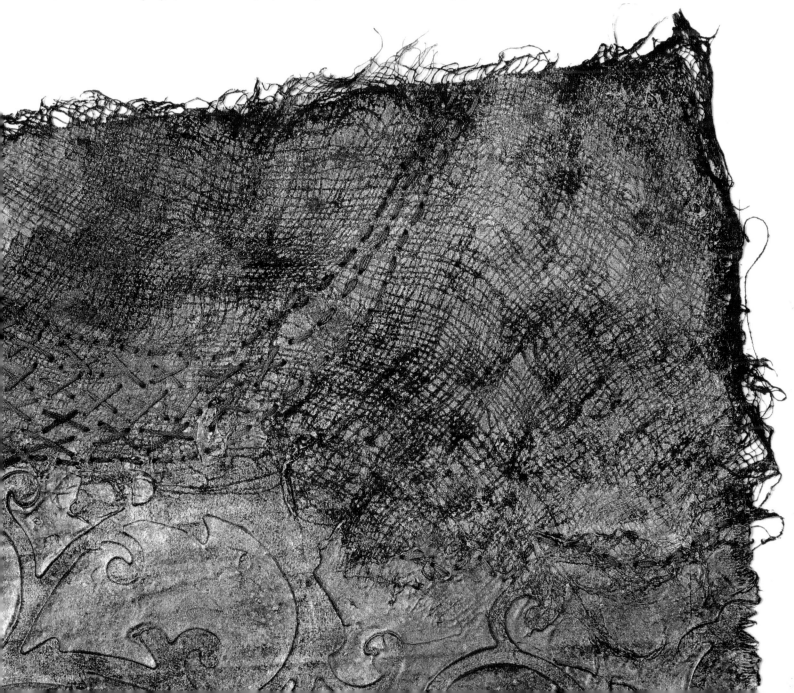

## COLOURING VILENE, SCRIM AND MOLDING PASTE

Experiment using sprays such as Moon Shadow Glitz Spritz over the whole surface while the molding paste is still wet. Then add metallic paint when the surface is dry – just on the raised areas. This creates a lovely contrast, especially on scrim, between the matt look on the scrim and the two-tone effect on the molding paste.

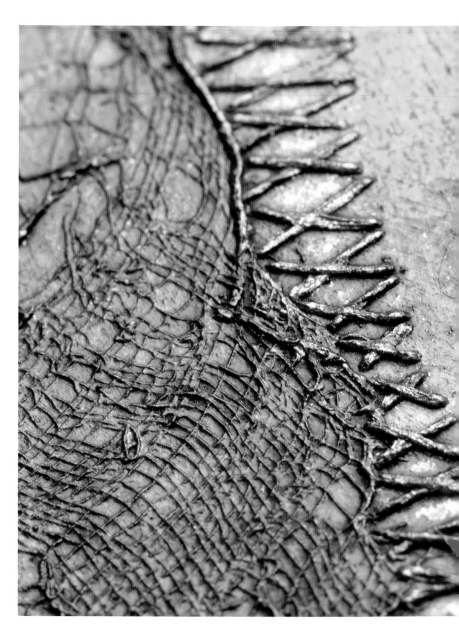

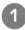

Molding paste could be applied to pelmet Vilene and stitch added before colouring. Here you can see the result when Golden Interference acrylic paint in Oxide Green (BS) and Oxide Violet were dry-brushed onto the fabric, covering the whole surface. Once dry, Moon Shadow Mist Burnt Umber was sprayed on top.

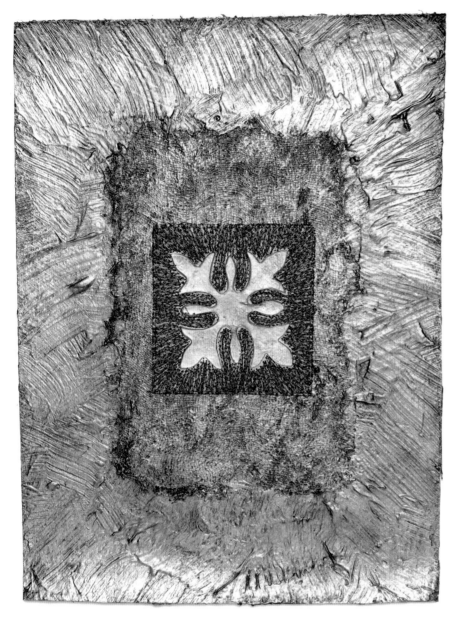

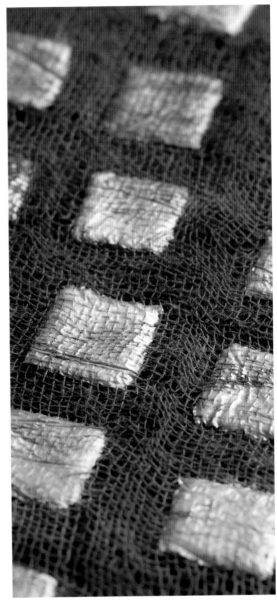

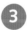

A base coat of black acrylic was painted over the surface of the pelmet Vilene. After allowing the black paint to dry, paynes grey and midnight blue were dry-brushed over the top. A simple design was stencilled with molding paste onto pelmet Vilene, painted in the same way and used as a focal point in the centre of the piece. A final coat of silver acrylic was painted over the whole surface and, once dry, Moon Glow Starburst Stains in Black Orchid Silver were sprayed on. The black stain settled into the crevices and highlighted the texture of the molding paste. Diluted black writing ink could be substituted instead of the stains. Metallic thread was used to stitch around the edge of the focal point.

A stencil was used on scrim and, once the paste was dry, the piece was turned wrong side up so that the surface of the molding paste showed the texture of the scrim. Koh-i-Noor watercolour paints were applied liberally to the whole surface. The colours remained really vibrant on the scrim and molding paste.

## MAKING A BOOK

To create this threefold book, work like this.

1 Stencil designs on scrim – as before.

2 Colour scrim and molding paste with Starburst Stain. Heliotrope Purple Plum was used in this piece; make sure the scrim is well saturated with colour.

3 Tear scrim around the molding paste shapes creating slips, ready to be applied to the base fabric.

4 Prime pelmet Vilene with gesso and spray with colour. We used Heliotrope Purple Plum.

5 Place the same mask that was used on the scrim randomly over the surface of the painted Vilene and sponge acrylic paint on top. We used magenta.

6 Cut the pelmet Vilene into three pieces and place them side by side, leaving a small gap in between each piece. The scrim slips can then be placed on the surface and stitched down, allowing the excess scrim to overlap onto the adjoining piece of pelmet Vilene.

7 Once all the slips have been attached, black card could be stitched to the back of each piece.

8 Make pages; ours were made from black Lutradur.

Threefold book made from pelmet Vilene and scrim.

## ALTERNATIVE SURFACES

Consider using the molding paste on a range of surfaces. We'll be looking at this in more detail later in the book but here are a couple of ideas for you to consider.

### Lutradur

Lutradur can be distressed with a heat tool; this gives some exciting options. Metal shim (or the inside of purée tubes) offers lots more options and metal leaf or foil can also be used. Here are some ideas.

For the centre sample below, Adirondack colourwash spray in Butterscotch and Eggplant were used on the wet molding paste and allowed to dry. Starburst Stain Heliotrope Purple Plum was sprayed over the whole surface and the exposed Lutradur was burnt away with a heat tool. This piece could then be pulled apart to create small additions to other surfaces.

BELOW: Molding paste on coloured shim.

BELOW RIGHT: Molding paste on Lutradur, distressed with a heat gun.

## Metallic surfaces

Molding paste can be stencilled onto metal shim, metal leaf and foil. For example:

- Metal shim can look great. Use masking tape to secure the copper to the work surface and apply the paste through a stencil. Leave until dry before you remove the stencil.

- Metal leaf will also work well. Bond the leaf to fabric (velvet is lovely) with fusible webbing. Then stencil as above.

- Before using the stencil, iron a square of Misty Fuse webbing onto gold or copper shim and then iron a coloured foil, perhaps purple, on top.

- Mix paint with the molding paste before stencilling onto the foil. This is easier than painting it afterwards.

BELOW: Misty Fuse was ironed onto copper shim. This gave a more lacy effect than Bondaweb (fusible webbing). Purple foil was ironed onto the surface and molding paste, coloured with silver acrylic paint, was stencilled on top.

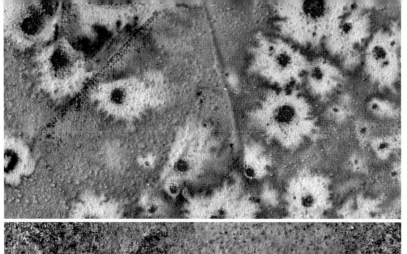

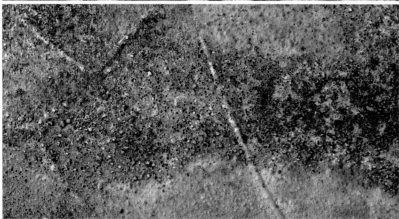

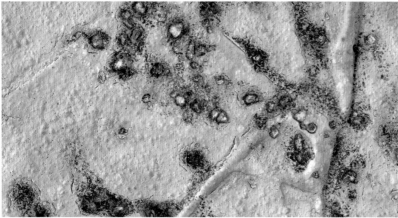

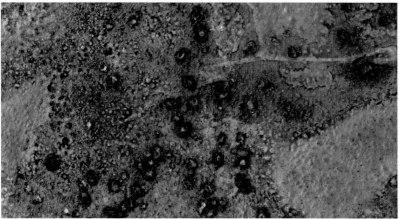

## COLOURING WITH INK, SALT AND BLEACH

This is an old favourite but a combination that never fails to give a really exciting finish. It can be used on wet or dry gesso or molding paste for different effects. Spraying the ink on the surface will also give a different result from painting it on with a brush.

### Ink

Quink fountain pen ink gives the most favourable results but try any of the inks you have and compare your samples. You may find a particular product that gives you the exact look you are aiming for but bear in mind that drawing inks do not usually react to bleach. Black writing ink has been used for these samples and finished pieces, but go ahead and experiment with different colour inks. Mixing two colours together can give a wonderful effect, especially if you intend to spray bleach on the surface. Mixing two or more different types of ink, especially if you use one that does not react to bleach, will also give a very exciting surface. If spraying the ink, dilute with water at a ratio of two parts ink to one part water. This helps it come out of the spray nozzle more easily and also makes it go further.

### Salt

All the samples and finished pieces have been created using either table salt or coarse sea-salt crystals. A number of different types of salt are available and are always worth experimenting with. Just a pinch of table salt or a few grains of sea salt are all that is needed. The effect can be lost if too much is added.

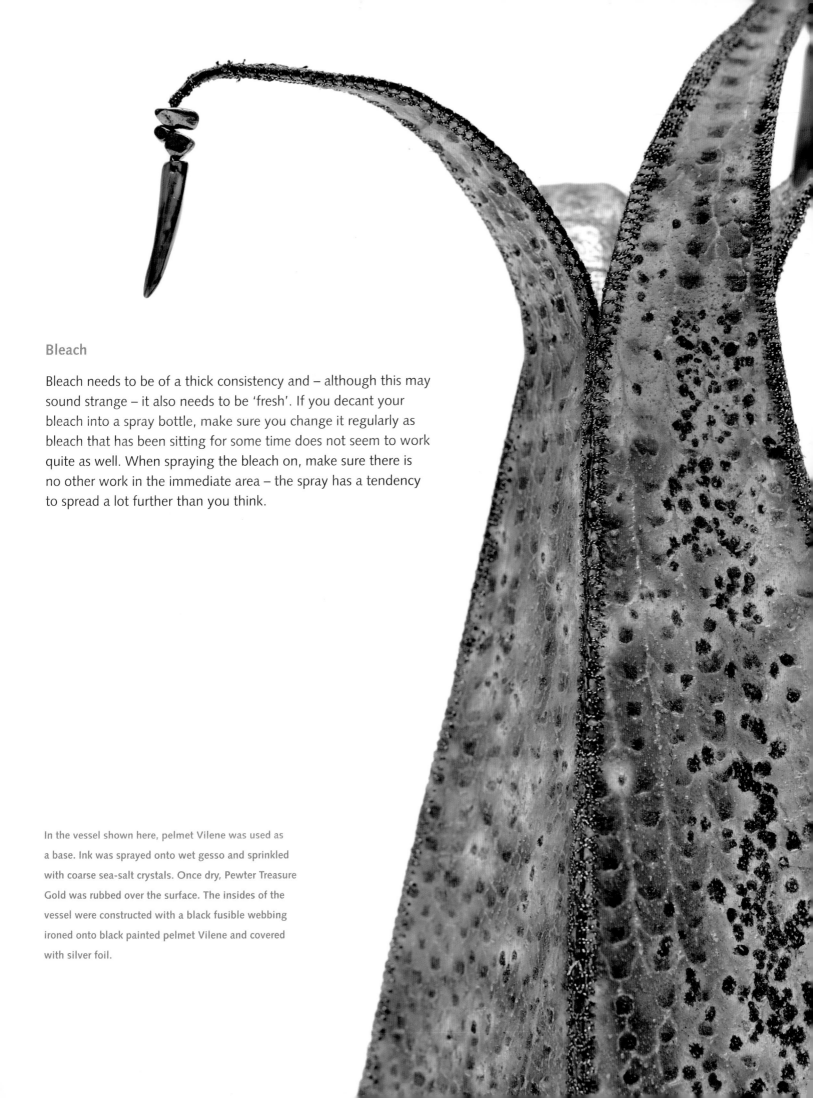

## Bleach

Bleach needs to be of a thick consistency and – although this may sound strange – it also needs to be 'fresh'. If you decant your bleach into a spray bottle, make sure you change it regularly as bleach that has been sitting for some time does not seem to work quite as well. When spraying the bleach on, make sure there is no other work in the immediate area – the spray has a tendency to spread a lot further than you think.

In the vessel shown here, pelmet Vilene was used as a base. Ink was sprayed onto wet gesso and sprinkled with coarse sea-salt crystals. Once dry, Pewter Treasure Gold was rubbed over the surface. The insides of the vessel were constructed with a black fusible webbing ironed onto black painted pelmet Vilene and covered with silver foil.

## WET GESSO

A thick gesso is required, preferably one that will hold its shape as you apply it, giving you a textured surface to work on. Use a spatula to apply it to the surface and spray immediately with diluted ink.

Now sprinkle on some salt. The ink will look very dark on application but, once dry, will lighten up considerably, leaving a darker outline around the areas where the salt has been sprinkled.

Leave the gesso and ink to dry thoroughly before adding bleach – there will be little or no reaction at all if you add the bleach while the gesso is still wet.

Make sure the gesso is completely dry before taking your samples a stage further. Drying times can vary considerably, depending on conditions. Shake or gently rub off any excess salt.

A further spray of ink, once the first layer is dry, will give the samples a darker finish.

Gesso was sprayed with black ink and salt was added.

## DRY GESSO

Wait until the gesso or molding paste is totally dry, then paint on the ink with a brush. Undiluted, straight from the bottle, is better for this technique. Sprinkle with salt while the ink is still wet. When the ink is completely dry, gently brush off the grains of salt. Table salt, especially, leaves a lovely shimmer on the surface in places.

Try the following:

- Paint the dry gesso surface with writing ink and sprinkle with coarse sea salt.

- Use dry gesso and table salt.

- Spray bleach on the surface while the ink is still wet or once it has dried. You could also try stencilling a pattern with bleach or write or draw into the surface with water brushes filled with bleach.

- Enhance the surface with hand or machine stitch, beading or by gently rubbing over the top with a gilding cream or wax.

For this hanging, heavy cotton calico has been quilted into squares. The gesso has been allowed to dry thoroughly before being coated with ink and just a few grains of coarse sea salt have been placed in each square.

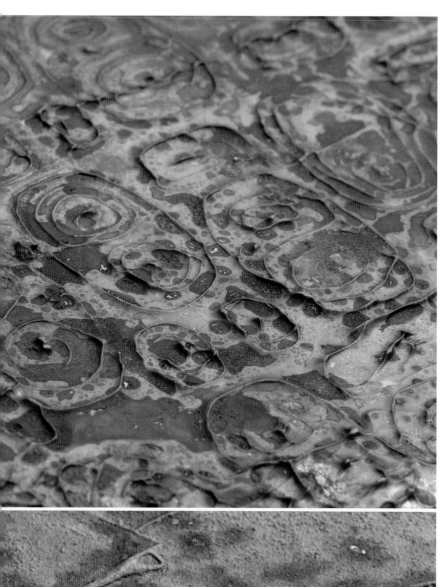

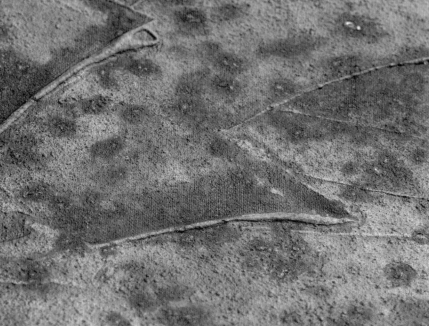

## MOLDING PASTE AND INK

Ink applied to wet molding paste dries to a much darker colour than ink applied to gesso and it also dries to a dull finish:

* Stamp a design into the wet surface before spraying the ink. This will give some interesting raised outlines which can be further enhanced with gilding cream, liming wax or Markal Paintstiks.

* Spray the wet molding paste with ink and sprinkle with coarse sea-salt crystals. Once this is dry, spray with bleach and rub the surface with Treasure Gold.

* Try dry molding paste, painted with writing ink, rubbed with Treasure Gold and then sprayed with Moon Glow's Glitz Spritz in Medieval Gold.

* A tarnished metal look can be created using stamped molding paste. Writing ink and coarse sea salt could be added while the paste is still wet. Once dry, apply Treasure Gold heavily, then wipe back using white spirit. Finally spray the surface with Moon Shadow Mist Burnished Brass. You can see this effect in the photo top left.

## OTHER INKS AND SPRAYS

Lots of different makes and types of inks are available and are worth experimenting with. Try the following ideas, spraying them onto both wet and dry gesso or molding paste surface, and compare the results.

* Walnut ink, sprayed onto wet acrylic and sprinkled with coarse sea-salt crystals, see left.

* Dry gesso painted with acrylic inks with coarse sea-salt crystals added. Treasure Gold could then be rubbed over the surface.

* Creative Colour Sprays and Moon Shadow Mists on dry gesso.

* The same sprays used on wet gesso.

## PREVIOUSLY TREATED SURFACES

These combinations can look equally effective on a textured surface that has been coated with gesso.

Here again, look out all those scrap threads, fabrics and lace that we all hoard, and give them a new lease of life!

Stitch fabrics and threads onto a background that is suitable for your purpose. If you intend to join the piece in some way, use masking tape around the edges to enable the seams to be sewn more easily.

Cover with gesso or molding paste, wet or dry, sprinkle with salt and then spray with ink.

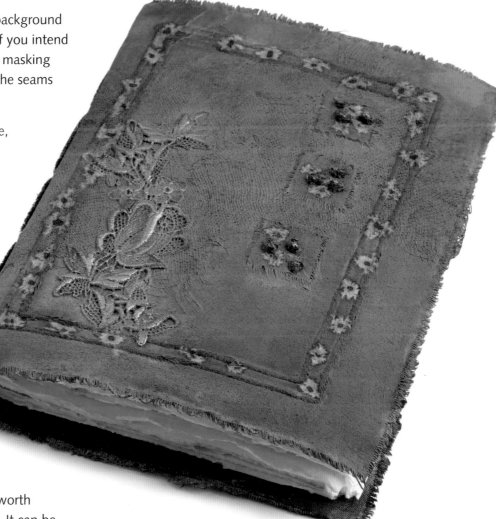

### CLEAR GESSO

Another wonderful product, well worth experimenting with, is clear gesso. It can be used in exactly the same way as regular gesso and molding paste: as a base layer, for stencilling, stamping and as a resist. Various colouring agents can also be added although, again, the colours will not be as vibrant. The gesso will dry to a clear or translucent finish depending on how thickly it is applied.

Book cover created with scrap thread, fabric and lace using writing ink and coarse sea salt on dry gesso.

# SECTION 2

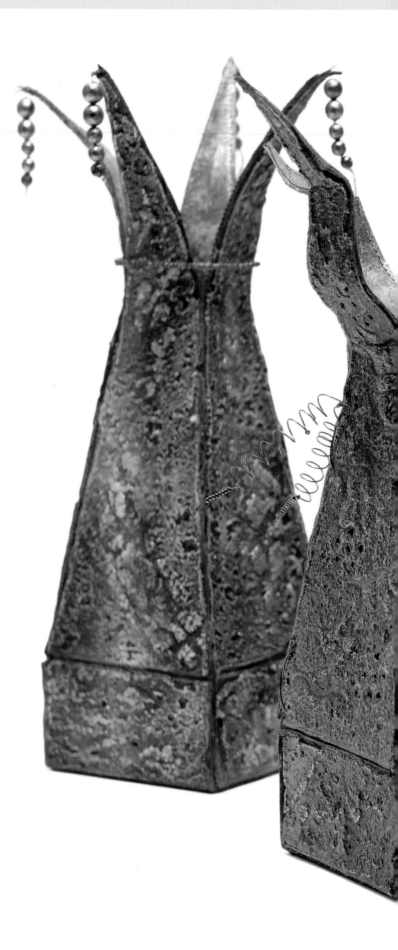

# Alternative surfaces

In this section we examine specific fabrics which, when used with gesso or molding paste, give a superb texture or effect.

## Kunin felt (acrylic felt)

Although we have specified kunin felt, any acrylic felt will work. The problem is that it is impossible to tell, when purchasing, whether the felt will react to heat and, for this reason, the felt that does work has become known as kunin. Although this felt comes in a variety of colours enabling you to create colourful textured pieces of work, you can take this zapped fibre to a new level with the addition of gesso and various colouring agents.

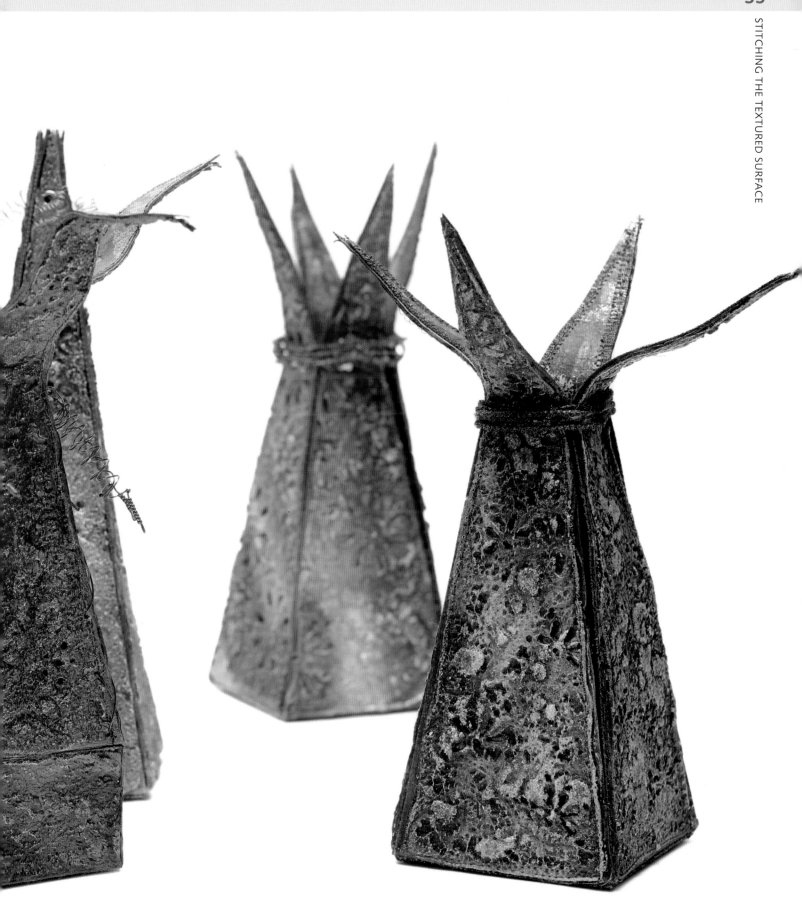

## KUNIN FELT

To create a textured surface as shown here, you will need pelmet Vilene and medium or heavyweight Lutradur as well as the kunin felt. It is not absolutely necessary to use the Lutradur; it just gives a slightly firmer finish and helps to prevent the pelmet Vilene from buckling too much with the heat.

As it is going to be covered in gesso, the colour of felt used is irrelevant although you will find that some colours melt back in a slightly different way from others. For a surface with crunchy texture after heating, our preference is for white felt. For a surface that has almost disintegrated when melted back, we find black is the best choice. You will also need a soldering iron and heat tool.

### SAFETY FIRST

Make sure you abide by all health and safety requirements and work sensibly. Always wear a mask or respirator when using a soldering iron or heat tool to zap or melt the felt. Work in a well-ventilated area and make sure you have plenty of space. Beware of burned fingers as zapped or burned fabrics will stay hot and sticky to the touch for a few seconds after melting.

A simple design is drawn on the pelmet Vilene. Try to choose a reasonably small design, without large areas to be burned out, as those can look very unsightly once the felt has been zapped.

Make layers: pelmet Vilene (drawing side down), then Lutradur and kunin felt. Turn the sandwich over to see the design and machine stitch in a loose circular motion on the background. The machine stitching acts as a resist, preventing the felt from melting back too far.

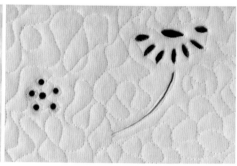

With the felt side uppermost, the outlines of the main design are then burned out using a fine-tipped soldering iron.

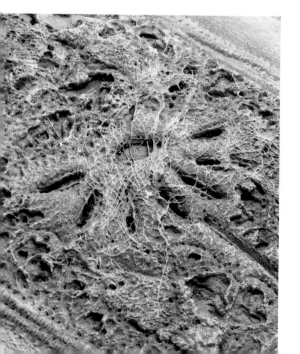

A thin layer of Xpandaprint (puff paint) can be added before zapping the felt to give even more texture. Use an old paintbrush or cocktail stick to apply the puff paint and be sure to wash any implements immediately after use. Apply the puff paint thinly; too much and you will end up with bubbles the size of footballs! You can use either white or black Xpandaprint. It will not make any difference to the finished appearance with this technique but you may find that the black does not 'puff' in quite the same way as the white.

When creating an object such as a vessel, it's a good idea to mould the felt into the shape required at this stage. This is because attaching it to a background before zapping or applying gesso makes it a lot easier to manipulate. It also allows for any seams or joins to be concealed with Xpandaprint or zapping.

The felt is then zapped and the paste expanded using a heat tool. Don't worry too much if you get over-zealous with the heat tool as the scorch marks will be covered with the gesso. Couched threads, and any other additions on the surface which are also to be covered in gesso, should be added now.

Cover the entire piece with gesso. Use sparingly on the zapped felt and heavily textured surfaces or some of the detail may be lost. Counteract this by working the gesso in really well with a stiff brush. Some of the Xpandaprint may chip off when you are brushing the gesso over. Remove these bits if this happens or you will have knobbly bits of texture in places where you don't actually want them.

If a dark-colour felt is used and, depending on the colouring agent you will be using on top, you may find a second (thin) coat of gesso is needed to cover the felt completely. A coat of white gouache before colouring will help to prevent some colouring mediums from being soaked up too quickly by the felt. If acrylic paints are used, a layer of white paint applied after the gesso and before colouring makes the colours far easier to blend into each other.

When the gesso is dry, you can use your choice of colouring agents to achieve the effect you desire.

A former, such as a sturdy cardboard tube or PVC pipe, could be used to mould felt into shape before zapping and applying gesso.

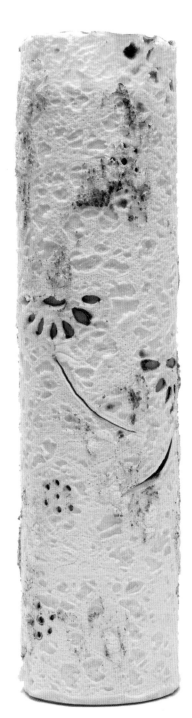

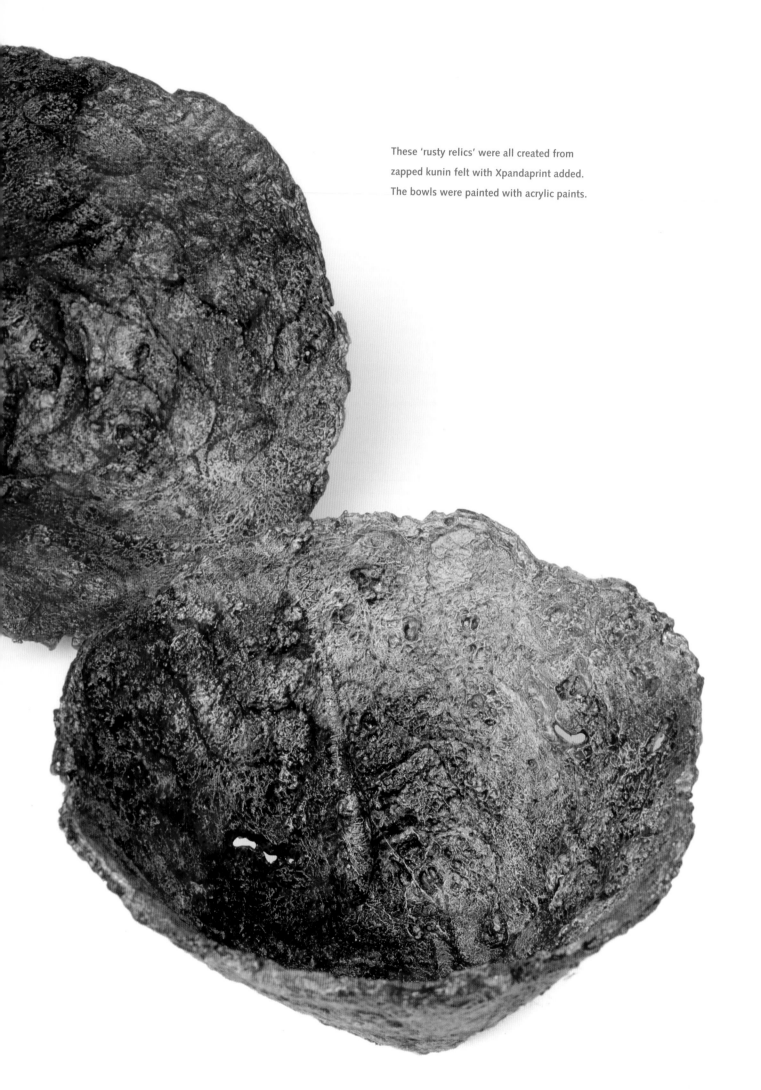

These 'rusty relics' were all created from
zapped kunin felt with Xpandaprint added.
The bowls were painted with acrylic paints.

More zapped kunin felt and Xpandaprint.
The vessel on the left was coated with
Metallic Effects iron paint with a rust
activator applied on top.

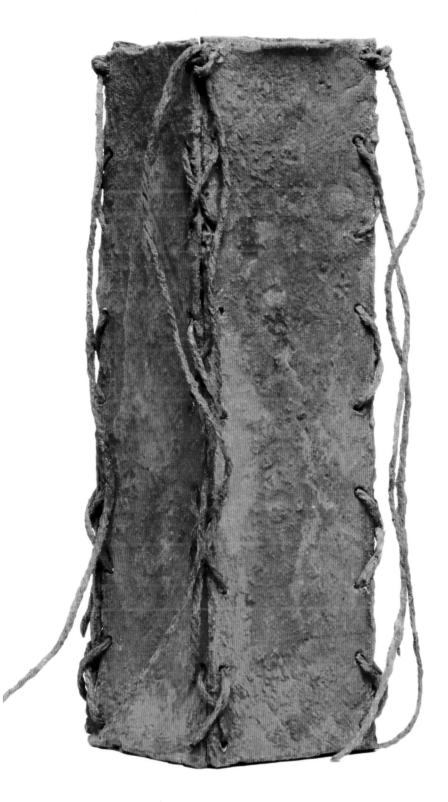

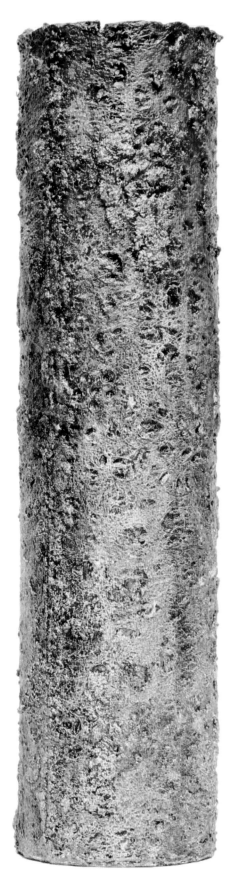

## QUILTED HANGINGS

Painted and quilted backgrounds make a wonderful surface to display small pieces of interesting and unusual textures. The instructions that follow describe the making process, using textured inserts from the previous technique. You don't have to be an expert quiltmaker to create one of these hangings as, fortunately, the gesso will cover any uneven stitch lines.

Heavy cotton calico and cotton duck canvas are ideal fabrics to use for this technique. Alternatively, you could recycle some cotton fabric from your stash.

Marking the outlines of a design on the top fabric makes it easier and quicker to stitch. A sharp pencil is preferable as some inks will bleed through the gesso and may even show through the colour applied on top. Leave spaces where you intend to stitch the textured pieces.

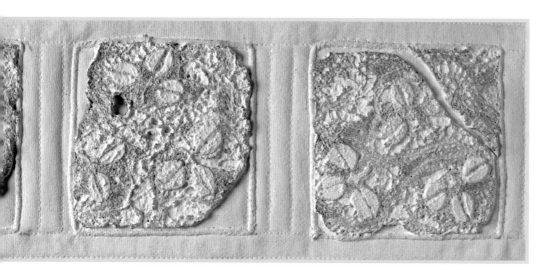

Once the design has been drawn, layer the top fabric with a batting (wadding) and a bottom layer of cotton fabric. Recycled woollen blankets make excellent wadding. Remember to allow enough fabric at the edges for turnings once the hanging is completed. It's also a good idea to use masking tape around the edges as they will be easier to turn under without a layer of gesso and paint on top.

As mentioned previously, the stitch lines are covered with gesso so there is no need to finish your threads by taking them through to the back of the work. Use the outside line of your design to stop and start the machining and, once all stitching has been completed, use a small zigzag stitch over this line to keep it neat.

If the textured inset has holes burned all the way through, therefore showing the surface of the hanging, coat with gesso the spaces where these textured insets will sit before stitching the piece down. This will give you a more even surface when applying the colouring media.

Affix the textured inset in place either by hand or machine stitching or by using an adhesive such as a heavy gel medium. Include any other additions before applying the gesso.

Apply the gesso sparingly on the heavily textured pieces to avoid losing any definition and, once completely dry, paint with the colours and medium of your choice.

In the quilted hanging shown here, the textured inset was fixed in place by machining. The whole piece was then painted.

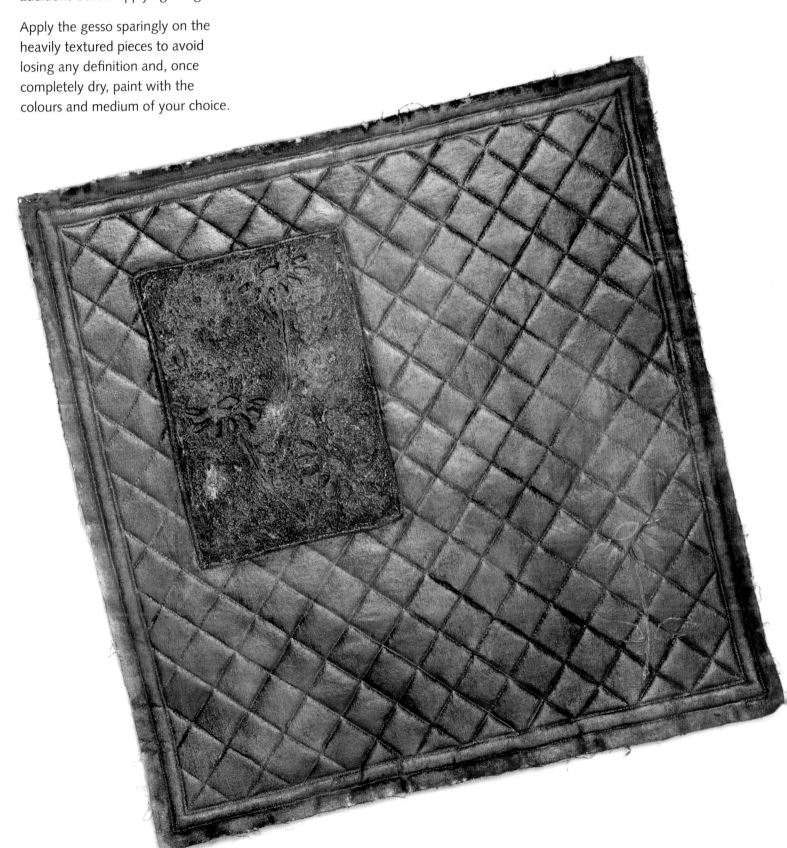

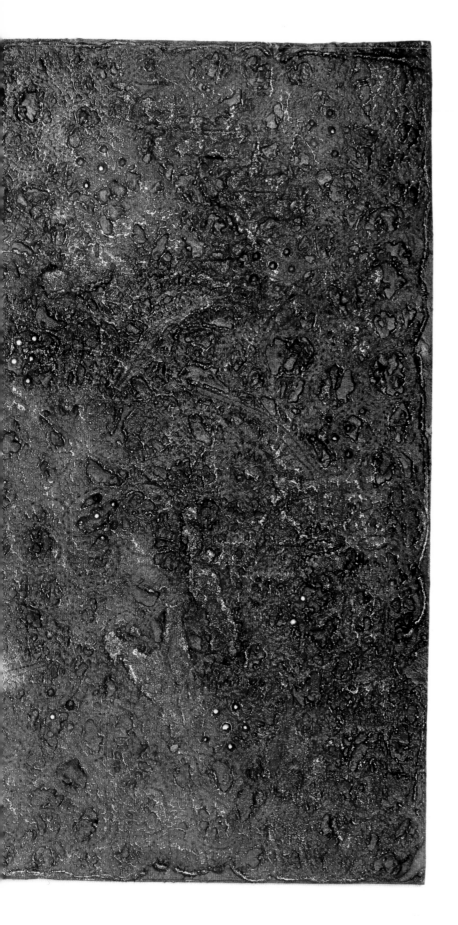

## Foiling

A smidgen of something glittery never fails to lift and enhance a surface and foil is an ideal choice for an acrylic painted surface, especially a heavily textured one, as no heat or adhesive is required. A smooth blunt metal object, such as the side of a spoon, is the ideal tool for applying the foil.

The acrylic paint needs to be dry but still tacky. If necessary, mask off the areas that are not to be foiled as even a hand resting on the surface will transfer a small amount of foil.

Place the foil, shiny side up, over the textured surface and gently scrape over the top with the side of the spoon. Don't scrape too hard or the foil will tear.

Keep the spoon moving over the whole of the surface. If you rub too heavily in one spot, you will end up with a solid block of foil.

LEFT: Gold foil applied to an acrylic painted and zapped kunin felt and Tyvek sample.
RIGHT: Detail of the piece on page 47 showing the Celtic stencil on zapped felt. Gold foil was applied to the stencil only.

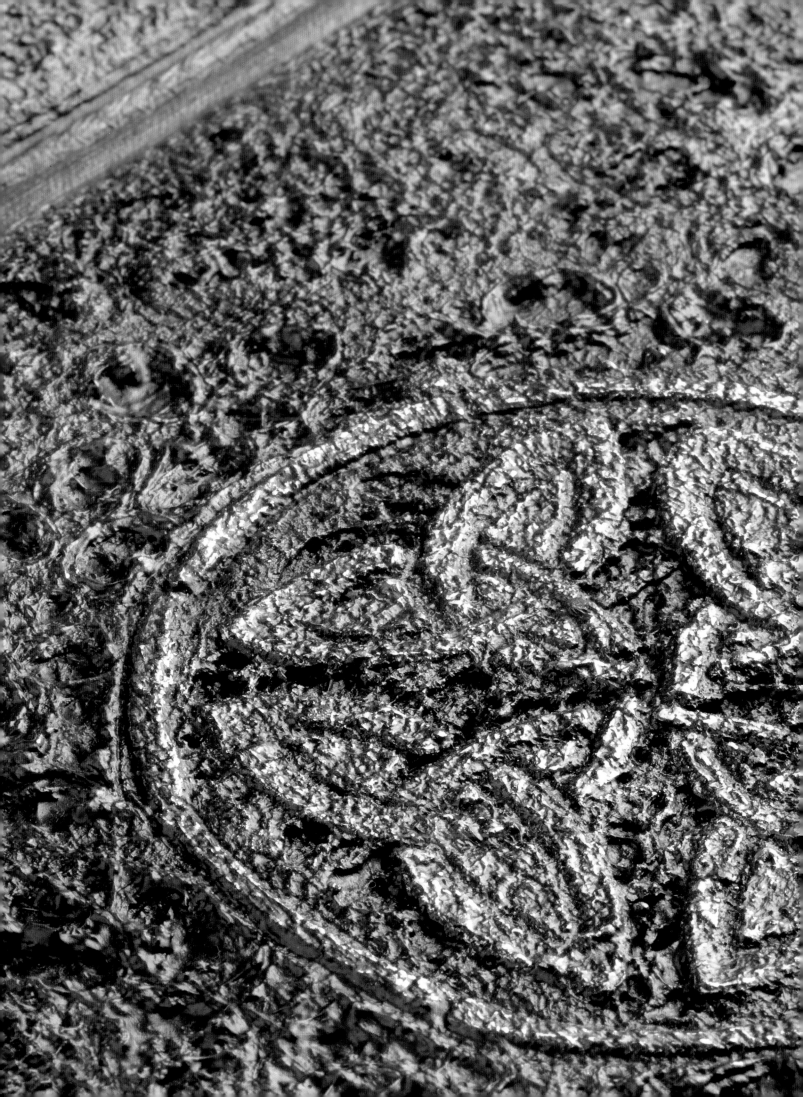

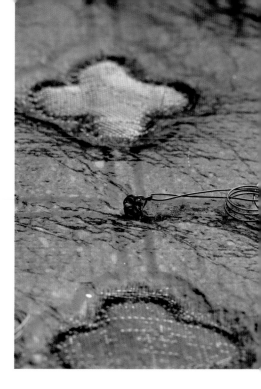

## REVERSIBLE QUILTING

A natural progression from a quilted hanging is a reversible quilted hanging, made by decorating both sides of the straight-stitched fabric. Work like this.

1   Mark your pattern on one piece of fabric and stitch as before, bearing in mind that this pattern will be in reverse on the flip side.

2   Turn the edges in at this stage before applying the gesso.

3   Attach the textured pieces to the hanging. Unless you are extremely confident that your stitching will match up on both sides, it is easier to stitch one textured inset in place on one side and glue the reverse one in position.

4   Then give the whole surface a coat of gesso before colouring.

Why not try a different technique on each side of the hanging? Apply gesso and paint to the whole surface and allow to dry thoroughly before attaching any inset.

### Tissue paper inset

1   For the tissue paper design, you need to use a laser printer or a waterproof pen. Choose a strong tissue paper: a wet-strength tissue such as Abaca tissue or repair tissue. Old dressmaking tissue paper patterns were used for this hanging. These are not quite as strong as the Abaca tissue but will withstand a lot of fluid before tearing or disintegrating.

2   Print or draw a design onto the tissue paper, cut to size and, using polymer medium, gel medium or PVA glue, attach it to the unstitched space on the hanging.

3   Wait for the adhesive to dry thoroughly, then overlay parts of the pattern with a transparent fabric such as organza and, using the outline of your design as a guide, machine the fabric in position. Trim the edges close to the stitching lines. As the stitches will show on the reverse side of the hanging, the inset for that side will need to be glued in position.

When using acrylic paints to colour the surface of these pieces, a coat of polymer medium will act as a varnish and help to level out the colours, especially if you have diluted them with water or rubbed them back. Be very careful, though, if applying any medium onto a heavily textured surface as it has a tendency to puddle and will dry out to a milky finish. It can also be used as an adhesive.

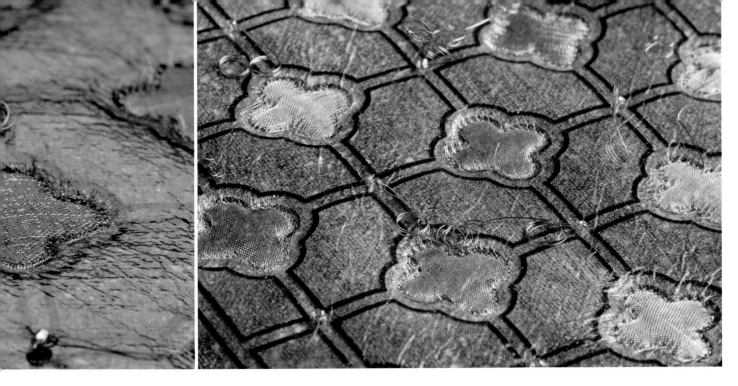

This reversible quilted hanging has a tissue paper inset on one side and a Tyvek inset on the reverse. These pics show the tissue paper inset.

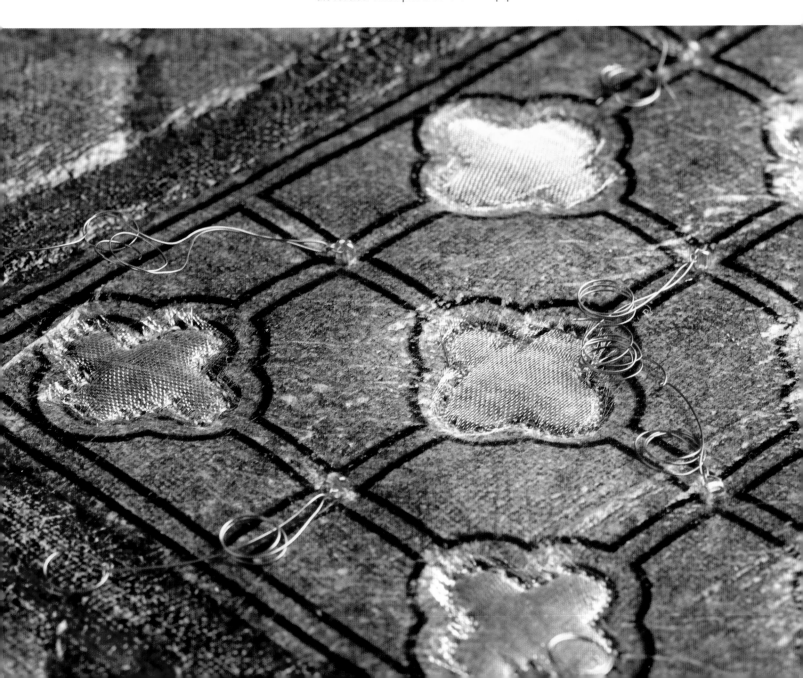

## USING GESSO OR MOLDING PASTE AS A RESIST

Using gesso or molding paste, either stamped, stencilled or brushed onto kunin felt, will act as a resist when zapping the felt. This will give you a solid design area with lots of crunchy texture in the background.

A thick-consistency gesso is needed for stamping or stencilling, with a lighter one for covering the entire piece. Molding paste can be used quite successfully for stamping or stencilling but you would still need to apply gesso to the background after zapping if you are going to paint the sample.

If necessary, use masking tape to hold the stencil in place on the felt while applying the gesso or molding paste. Remove the stencil carefully to prevent any smudges.

These samples were backed with medium or heavyweight Lutradur and pelmet Vilene. One or two layers of felt could be used, depending on how sturdy the finished pieces need to be.

BELOW: Molding paste stencil with Creative Colour Sprays, Moon Shadow Mists and Brass Treasure Gold.
LEFT: Molding paste stencils.

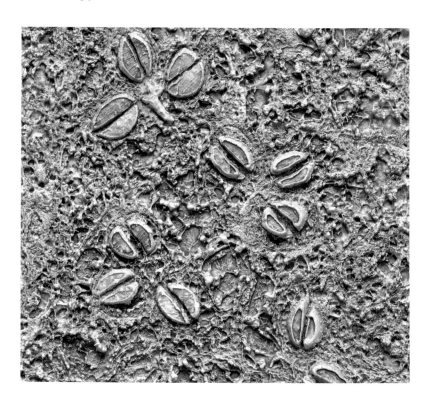

The stencilled designs we have chosen to show the basic techniques are all very simple. Any stencil that gives a clear outline can be used and the addition of couched threads, beading or wire will certainly enhance the surface. Here's how.

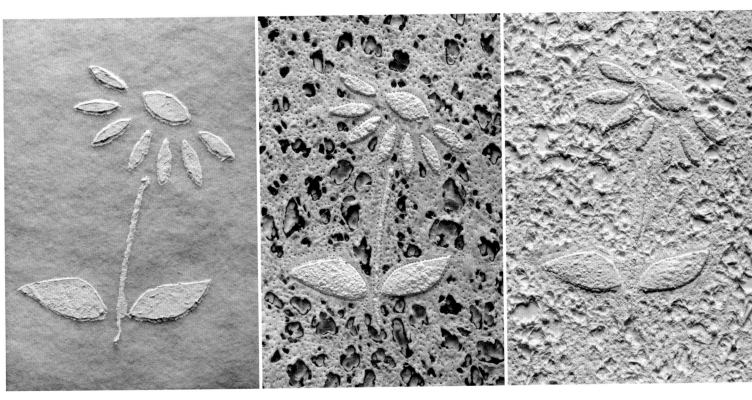

1  Use the stencil, as before, to make a clear shape on the felt.

2  Allow the gesso to dry and machine stitch carefully around the edges of the design, taking care not to stitch through the gesso or it may crack or flake. The design needs to be stitched around; otherwise, when the piece is zapped and the felt distorts, the gesso will lift and buckle.

3  The background is then machined using a freehand circular motion and the whole piece is zapped with a heat tool.

4  Another layer of gesso is used to cover the entire background and brushed thinly over the top of the stencilled design.

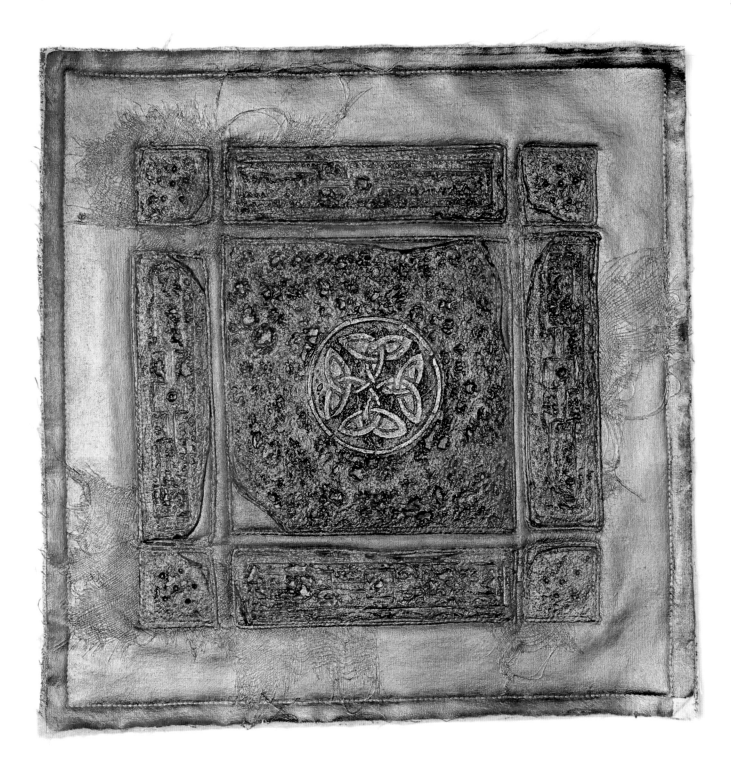

## COLOURING THE SAMPLES

The samples can then be coloured in a variety of ways and will be ready for further embellishment.

LEFT: Molding paste stencil, acrylic inks and white Markal (Shiva) Paintstik.

The centre piece on the hanging above has a Celtic knot which was stencilled in gesso before the felt was zapped. The borders were machine stitched and the pattern was burned out using a soldering iron before applying gesso and painting with acrylic paints. When the acrylic paint was dry but still tacky, gold foil was rubbed over the surface of the stencilled design.

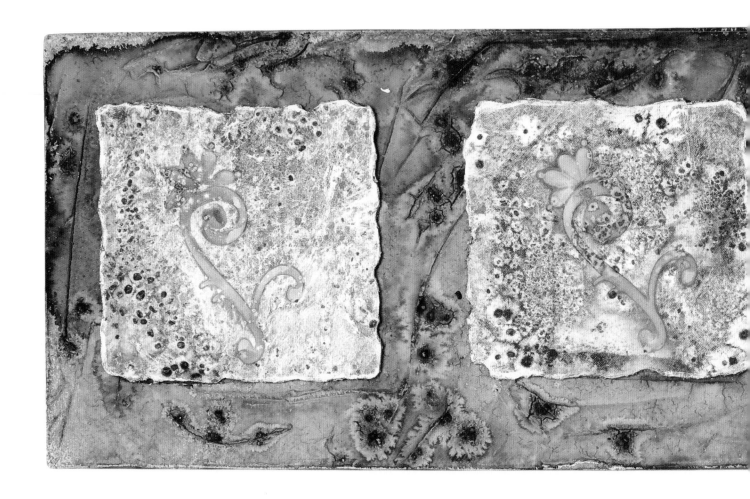

# Tyvek

Tyvek will take both wet and dry colouring mediums very well. It can be coloured before or after heating. Acrylic paints, metallic and iridescent paints, fabric paints and dyes, watercolour, pastels and crayons – the list is seemingly endless. You will find baby wipes are really useful. Use a supermarket's own brand; not only are they drier than the more expensive makes but they are also usually plain, rather than printed with teddy bears and such. Keep all your baby wipes, dry them out and press with a cool iron. You will then have a bunch of gloriously coloured surfaces to work with. They can be stitched into or used with the embellishing machine.

If Tyvek is heated, the colours used may react to the heat, resulting in a variety of colour intensities, so make sure you bear this in mind when planning a project and test a small area first.

These samples and finished pieces were all created using 100g Tyvek paper. Other varieties of Tyvek could be used but the results may be slightly different.

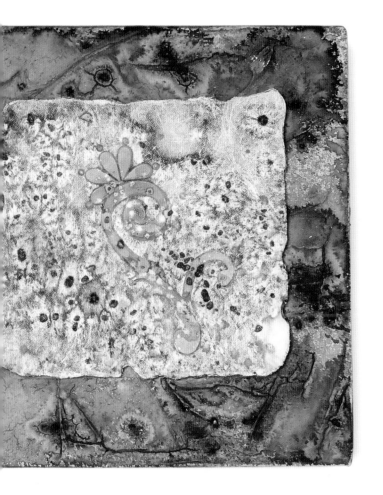

An extra large helping of whiting was added to the gesso used as the base of this box canvas. Black writing ink and coarse sea salt were added to the dry gesso; this caused it to crack in places, giving a very pleasing effect.

## COLOURING TYVEK

1 Load a brush with diluted acrylic paint or other colouring medium and apply all over the surface of the Tyvek. Work quite quickly as the fluid is soaked up rapidly. Several thin layers are preferable to one thick, heavy layer.

2 Use a piece of sponge, kitchen towel or, better still, a baby wipe to rub the colour into the Tyvek until you see the grain showing through.

3 Flip over the sheet of Tyvek and rub across the back. No need to use the paintbrush; enough paint will be soaked into the sponge or baby wipe to cover the reverse adequately. It is always best to colour the back as, when the Tyvek is heated, the edges may flip up and show the reverse side.

4 If the colour is too light then wait until this layer is dry before applying another. Some great results can be obtained by adding layers of colour in different shades.

5 Lay a sheet of plastic or a refuse sack on your work table when applying colour to Tyvek; the results on the reverse side can be amazing.

Silk paints and disperse dyes used on Tyvek.

Silk paints used on Tyvek.

Here are some more ideas for painting Tyvek.

- Iridescent metallic acrylic paints can look very effective when applied to the Tyvek paper.

- Water, bleach or a different colour of acrylic paint dripped onto the wet surface will give unpredictable results. Water dripped onto an acrylic surface can take some time to dry.

- Use silk paint or disperse dyes. These could be diluted before use.

- Walnut ink gives an aged look to the surface of the Tyvek paper. Try sprinkling a few of the walnut ink granules on the surface before it dries. It reacts well to salt and a great effect can be obtained by sprinkling the granules onto wet Tyvek.

- All types of ink will colour Tyvek successfully although, when combined with the salt and bleach techniques, the writing ink still seems to work best. Try some of the techniques from page 26.

Don't limit yourself to your normal supplies of paints and dyes. Be adventurous and try some unusual colouring agents.

Tyvek was painted with silk paint and then, while this was still wet, a different colour was sprayed on top.

Tyvek with black writing ink and sea salt – reverse side.

## TYVEK PAINTED WITH POTASSIUM PERMANGANATE

Potassium permanganate, used as a disinfectant, is available from chemists, pond suppliers and garden centres. The crystals are dissolved in warm water to give a deep purple solution. On evaporation, it changes to a brown or purplish-black colour. Protect your hands and clothing as it will rapidly stain virtually any organic material. Apply the solution to the Tyvek paper and watch it change from purple to brown as it dries.

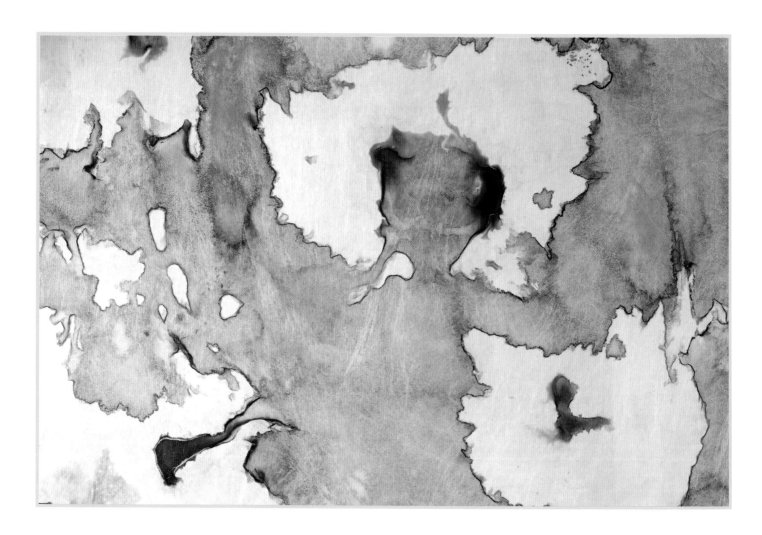

ABOVE: Coarse sea salt was sprinkled on to the surface of the Tyvek while the Potassium Permanganate was still wet.

OPPOSITE: Lemon juice was dripped on to the Tyvek while the Potassium Permanganate was still wet.

## TYVEK WITH A RESIST

You can use gesso or molding paste as a resist. Just stencil or stamp your design onto the Tyvek paper using either.

For stencilling, you will need a heavy gesso to prevent it from seeping underneath. The surface of the Tyvek paper is quite slippery, so it can be a good idea to use masking tape to hold the stencil in place. Apply the gesso or molding paste and leave to settle for a few minutes before carefully removing the stencil.

The Celtic knot design on the front of this book cover was stencilled onto Tyvek using gesso. Acrylic paints were used first, followed by a heavy layer of Pewter Treasure Gold. This was then wiped back with white spirit and Moon Shadow Mists were applied on top, giving the piece a distressed feel. Detail below.

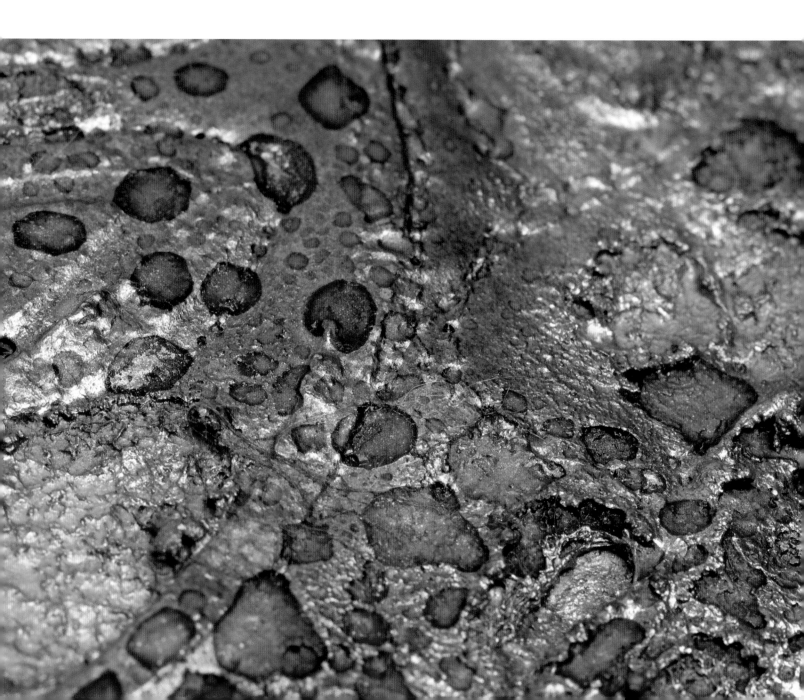

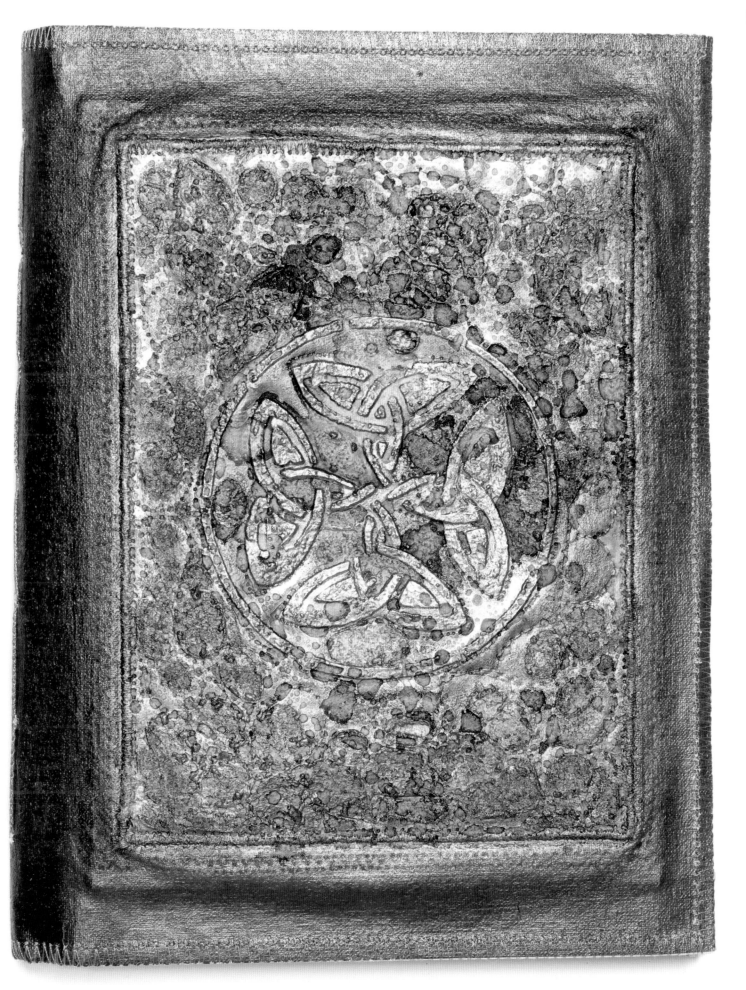

## THE BASIC RESIST TECHNIQUE

Any of the colouring methods previously shown can now be applied to the wet or dry gesso. Here's the method.

  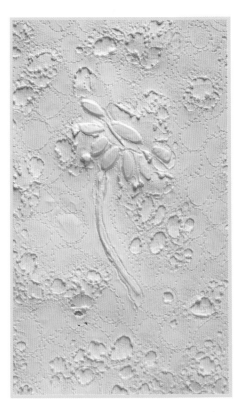

1 Stencil or stamp your design onto the Tyvek paper using either gesso or molding paste. Allow to dry.

2 The paper could be stitched to a ground fabric before or after colouring.

3 Machine stitch around the design areas, taking care not to stitch into the gesso or molding paste as this may cause cracking or flaking.

4 Once the main design has been stitched, use a freehand circular motion or stitch wavy-lined squares on the background. This will prevent the Tyvek from melting back too far.

5 Use a heat tool to zap the Tyvek gently. Although the stencilled design will seem to have lost some definition at this stage, it will show up more clearly once it is coloured and highlighted.

6 Now colour in the medium of your choice. Colouring media can be used before or after stitching. This piece has been coloured before stitching, using black writing ink sprinkled with coarse sea salt and sprayed with bleach. When this was dry, the Tyvek was stitched to a patterned piece of black velvet before zapping.

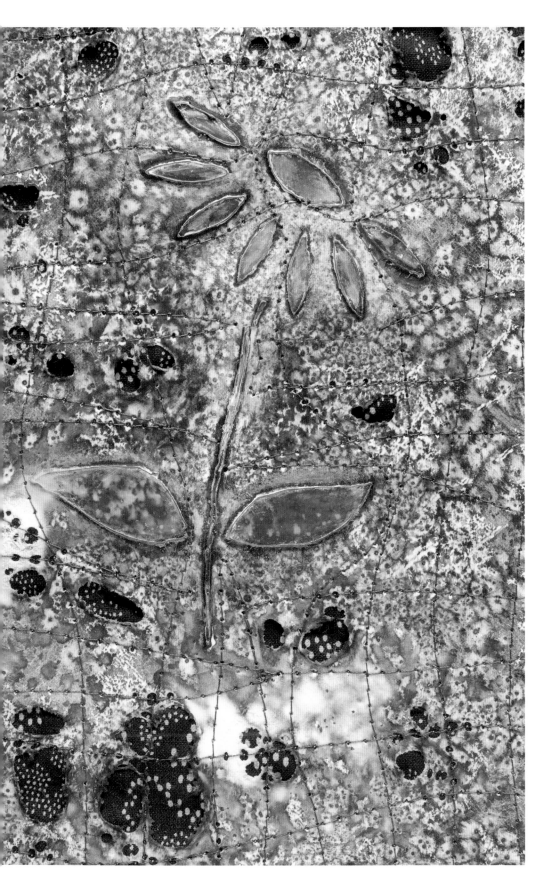

It is possible to stitch and zap the Tyvek after colouring. If you do this, you will need to consider the background fabric. Choose a fabric that is able to withstand the heat: cotton and velvet are a good choice. For extra stability, layer the fabric with pelmet Vilene. Finally, machine stitch, using a matching or contrasting thread that will also withstand the heat.

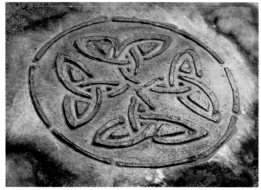
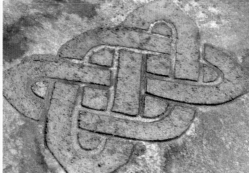
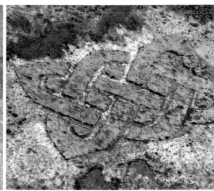

## COLOURING TECHNIQUES

Consider some of the following treatments:

- Use Creative Colour Sprays and Moon Shadow Mists.
- Try writing ink with salt.
- Spray bleach onto the surface to discharge the ink.
- Sprinkle bronze metallic powder into the wet ink surface and lightly brush off when dry. Try adding coarse sea salt to this mix for yet another effect.
- Spray bleach onto the surface to discharge the ink.
- Sprinkle bronze metallic powder into the wet ink surface and lightly brush off when dry. Try adding coarse sea salt to this mix for yet another effect.

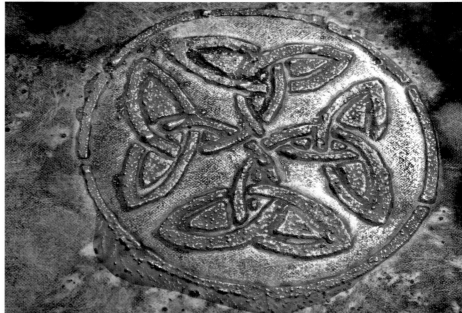

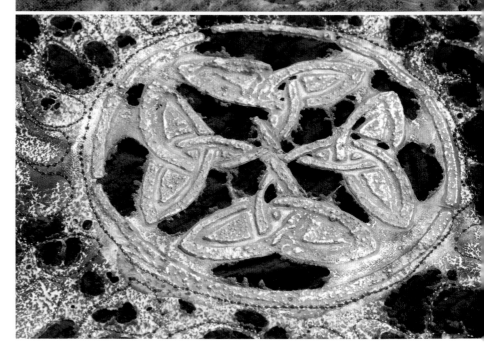

ABOVE and RIGHT: Various colouring techniques.

BOTTOM RIGHT: The stencilled design shown here was rubbed with Pewter Treasure Gold. The Tyvek was then placed onto a piece of black velvet with pelmet Vilene before being zapped.

## TYVEK SHADOWING

A great effect can be achieved after colouring by carefully removing the gesso from the Tyvek, leaving a shadowed outline which could then be filled in with a contrasting colour. Hand stitching or beading would look equally effective in the spaces.

Remove the gesso with a palette knife, taking care not to dig into the paper as it may tear. The gesso will usually come off in whole sections at a time. These could then be re-used in other projects by adhering them to the surface with a gel medium.

Extend this technique by mixing a bronze metallic powder with the gesso before stencilling onto an ink and bleach background. Allow to dry and carefully remove the gesso, leaving a copper-coloured outline on the Tyvek.

This sample was coloured with black writing ink and sprinkled with coarse sea salt. When the ink dried, the gesso was removed carefully.

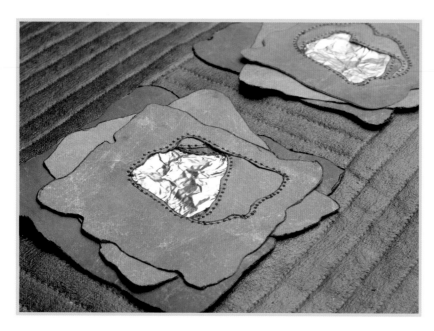

ABOVE: The insets on this acrylic painted hanging included coloured Tyvek shapes laid over metal shim and stitched in place with a matching metallic thread.

## TYVEK UNZAPPED

It is not always necessary to zap the Tyvek to achieve a wonderful effect. In these finished pieces, gesso was stencilled onto the surface of the Tyvek. Then irregular squares were cut, using the tip of a soldering iron. In all cases, gel medium was used to attach the Tyvek to a prepared background.

The photograph opposite shows a quilted hanging, made using this method.

1  The calico backing was first quilted and then painted with acrylic paints.

2  The Tyvek was stencilled and painted with acrylic paints using the same colour as the background.

3  It was then cut into rough squares with the soldering iron.

4  The tiles were applied to the background using Gel medium.

ABOVE: Gesso was stencilled onto Tyvek before colouring with ink, coarse sea salt and bleach. Irregular squares were burned with a soldering iron and were then given a brush of black ink around the edges to highlight.

# Lutradur

Lutradur is a non-woven polyester material which is available in several weights from 30g to 130g. A very versatile fibre, it has many useful properties:

- It will withstand the heat of an iron to apply transfer dyes, but melts easily using a heat tool or soldering iron, creating interesting effects.
- It takes image transfers using gel medium, can be stamped or stencilled and, depending on the weight of the Lutradur, can also be run through a printer.
- It can be coloured with transfer dyes, acrylic paints, silk and textile paints, Koh-i-Noor watercolours, Moon Shadow sprays, crayons and chalk pastels, ink pads, writing ink and colourwash sprays.
- Adding light washes of colour gives a translucent effect to the surface.
- Layering the Lutradur allows the colours to shine through.

Bear in mind that colouring the Lutradur with inks or sprays first makes it easier to burn with a heat gun. Acrylics give more resistance so, if you wish for a lacy effect, keep this in mind when planning your project.

## LUTRADUR AND PELMET VILENE VESSEL

The look of old corroded metal was the inspiration for this vessel. The oxidisation reveals layer after layer of glorious colour. Lutradur is perfect for this effect as, once it has been zapped with the heat tool, it begins to buckle, creating an interesting surface.

To create the base of the vessel, use heavy pelmet Vilene. This is an extra-thick Vilene with heat-activated adhesive on one side. Lutradur 70 was used for the top layers of the vessel.

Draw the template for the vessel (consisting of a front, back, two sides and a base) on thin card. A simple vessel using a tube shape, which would require only one seam and a base, could also be made to look stunning with this technique.

This vessel used zapped Lutradur to capture the effect of corroded metal.

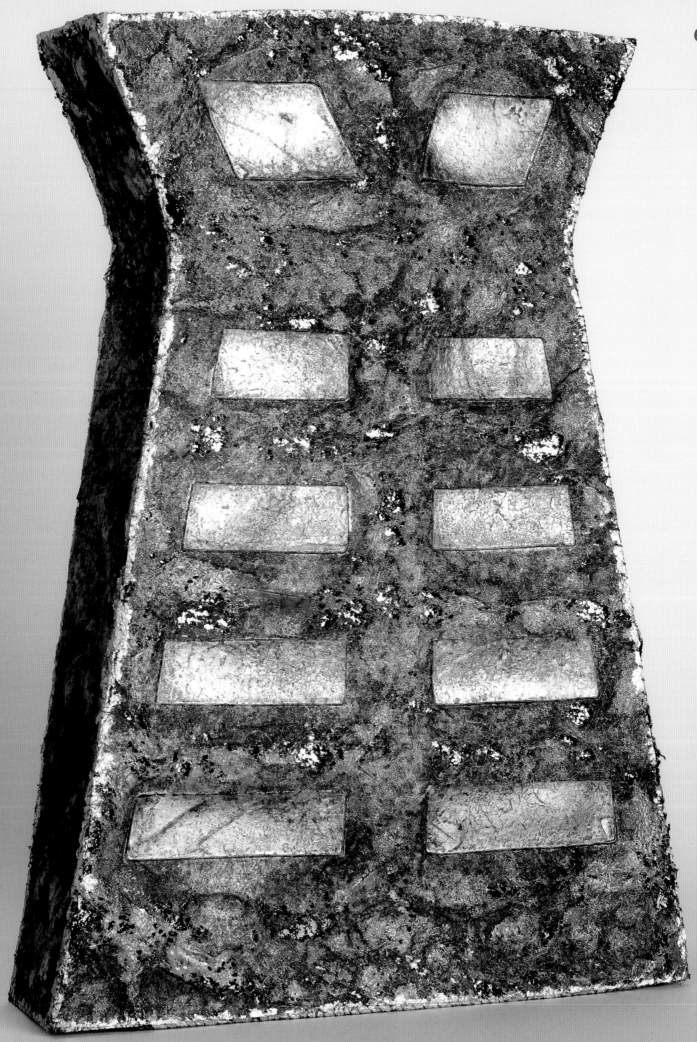

 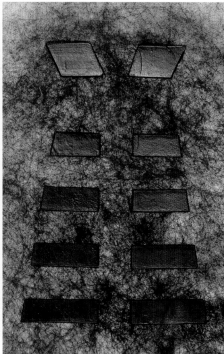 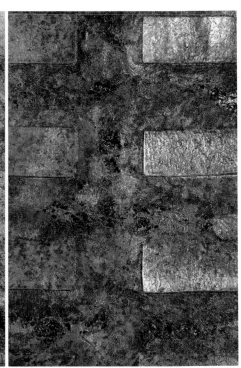

1 With the adhesive side facing upwards, paint black writing ink over the whole surface and, once dry, apply copper foil over the inked area.

2 Molding paste can then be applied to the top layer – the Lutradur. Try using a home-made stencil and Adirondack colourwash spray. Here, colours Stream and Raisin were sprayed on, while the molding paste was still wet, and then allowed to dry thoroughly.

3 The Lutradur was then heated carefully with a heat tool until a lacy effect was achieved. You will notice that the colour becomes very dull at this stage.

Now apply layers of colour using acrylic paints in burnt sienna, teal, turquoise and sea mist. The paint should be sponged on gently, starting with the darkest colour and building up to light. Then the completely dry surface was sprayed with Moon Shadow Glitz Spritz, Royal Peacock Fire, and once more allowed to dry.

Once all the colours had been added, the vessel was assembled.

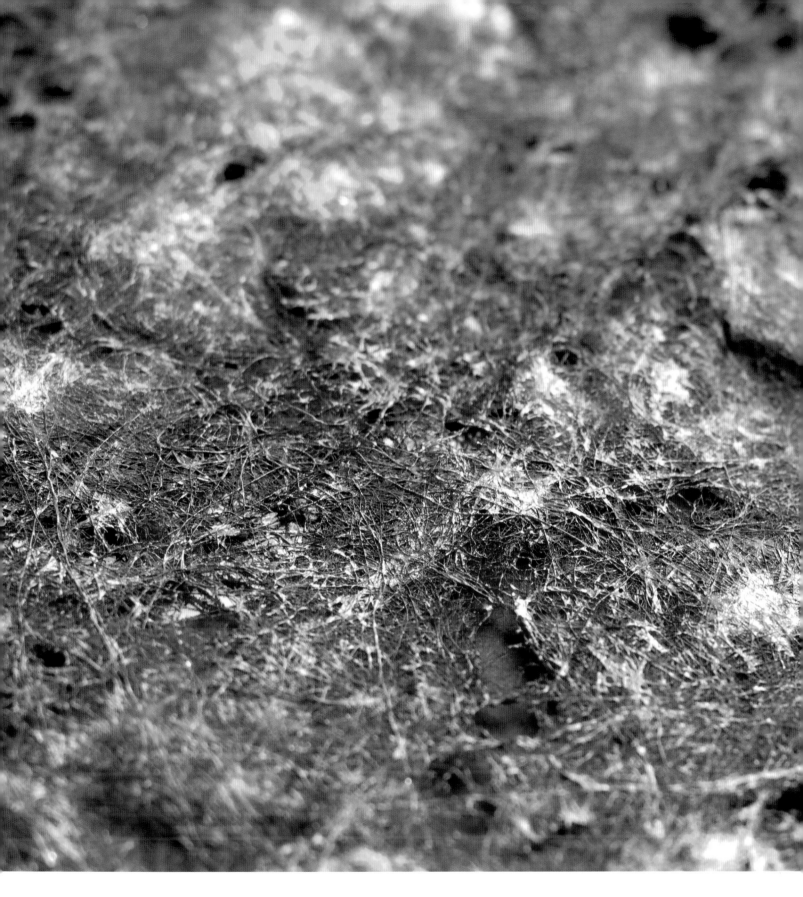

A different effect could be achieved by sponging copper
acrylic on the surface in place of the Moon Shadow Mist.
Adding the acrylics after heating would give the Lutradur
a crunchy texture, like corroding metal.

## LUTRADUR AND SCRIM PANEL

1 A square of Lutradur was first sprayed with walnut ink and turquoise colourwash and allowed to dry.

2 As an alternative to molding paste, glass bead gel was stencilled onto scrim and sprayed with Butterscotch and Stream colourwash.

3 The scrim was stitched to the Lutradur with wavy lines in between the glass bead gel to secure in place, and then taken out to the edges of the scrim.

4 The Lutradur and scrim were placed on a heat-resistant mat and a heat tool was used in a circular motion to give even coverage around the outer Lutradur fabric.

The heat from the gun tends to dull certain colours, so a Moon Shadow Mist, Mystic Malachite, was sprayed over the surface.

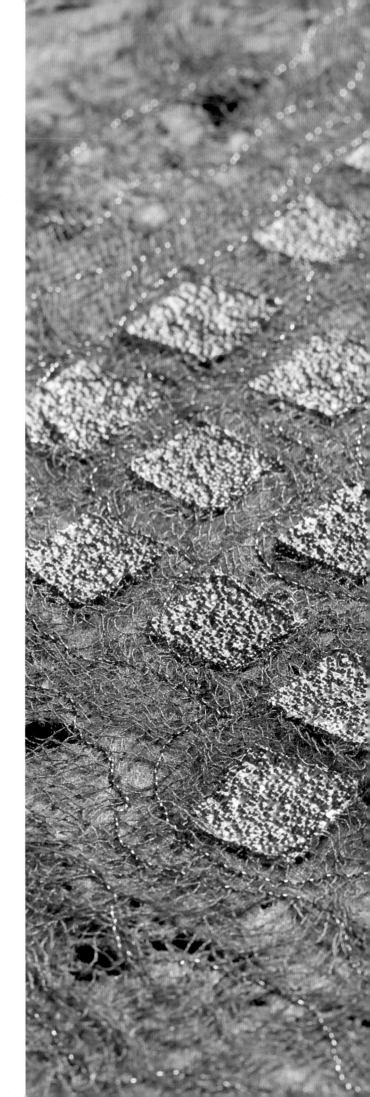

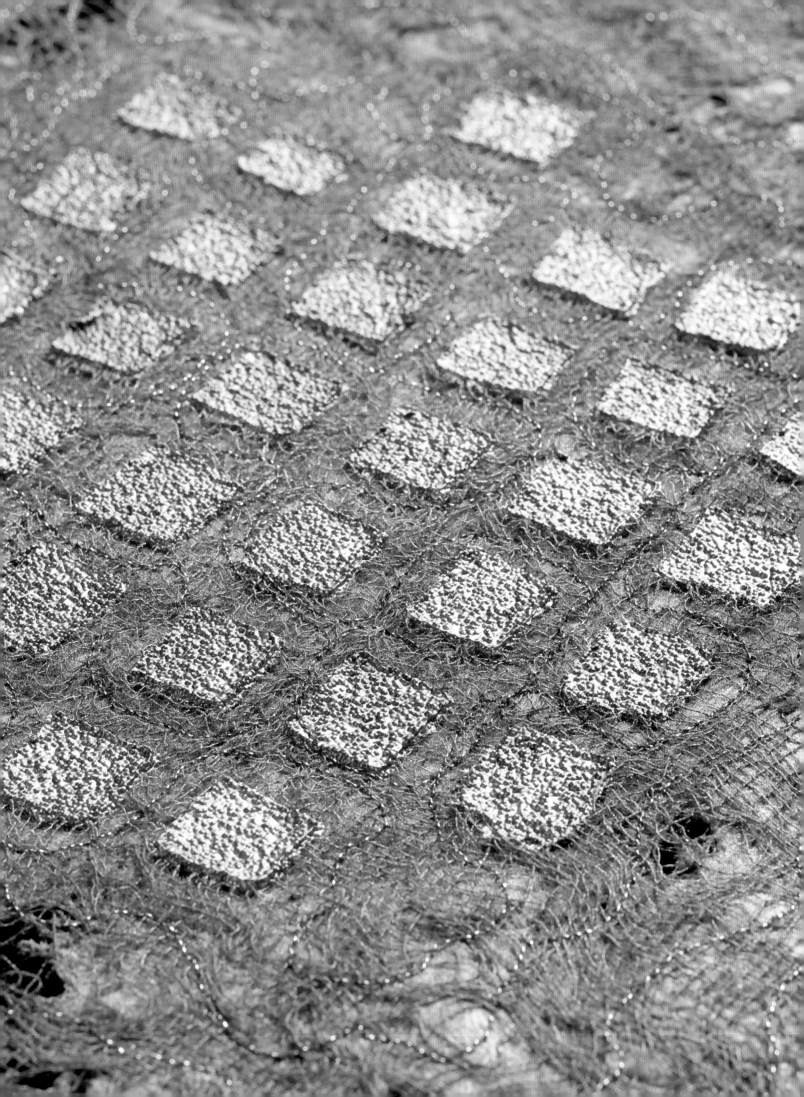

## LUTRADUR AS A BASE FABRIC

Lutradur works well as a base fabric for hangings as it will readily take paint along with the addition of textured wallpaper, scrim and stitch. Mosaic floors, frescos and old pathways among the ruins of Ephesus inspired this panel.

1 A slip of scrim with molding paste applied was free machined to the Lutradur along the edge to secure it in place. A cotton thread was used for the machine stitching and the added hand stitching. Cotton thread will readily accept wet mediums, which enables it to blend into the background.

2 Golden's acrylic paints were used throughout, starting with a base coat of fluid acrylics in Transparent Red Oxide and Quinacridone Nickel Azo Gold. These were blended over the surface using a wet brush. See pic right.

3 Torn pieces of textured wallpaper were fixed in place with PVA glue. The squared pattern echoes the design in the mosaic stencil. Try to choose a wallpaper that is sympathetic with the rest of your design.

4 Burnt umber, raw sienna, yellow ochre, red oxide and phthalo turquoise were then dry-brushed over the surface. Even though these layers will be covered with the top layers of paint, the range of colours used gave a rich depth to the final result. See pic far right.

5 More machine stitching was added before a final coat of Interference Oxide Green and Iridescent Bronze were added.

ABOVE: Old walls and pathways were the inspiration for
this piece which used Lutradur 70. Two stages can be seen
here with the finished piece shown overleaf.

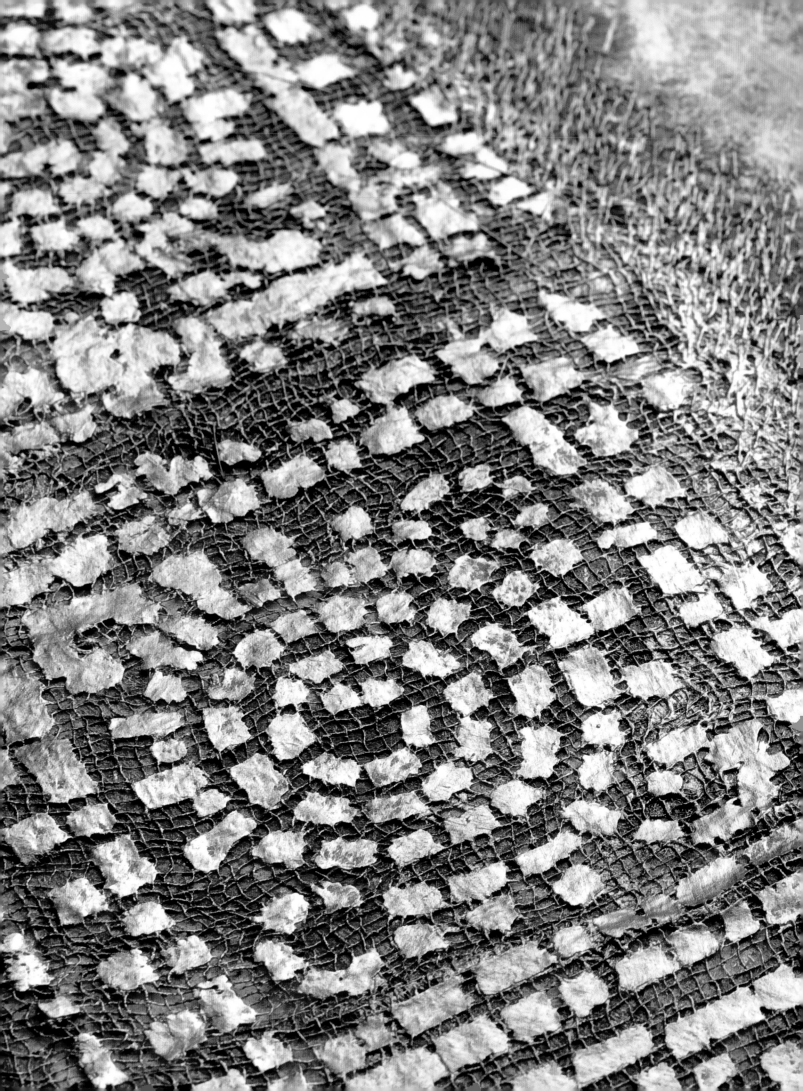

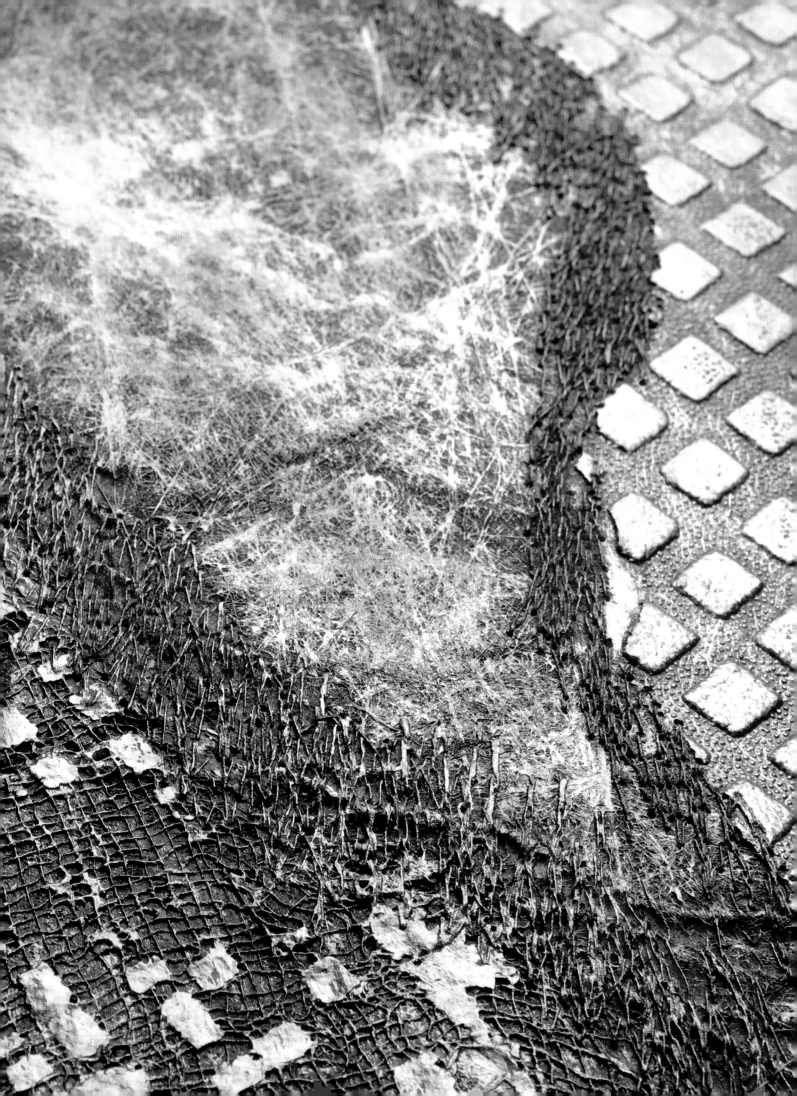

## USING GESSO AS A RESIST

Lutradur, like Tyvek, does not necessarily have to be subjected to heat to create some amazing surfaces.

Gesso and molding paste will both work really well as a resist on Lutradur with some fabulous results. They can be stamped, stencilled or brushed onto the surface.

## STENCILLING

Thermofax screens can be used successfully with a thin gesso but are unsuitable for molding paste due to the consistency. If using a thermofax screen, be sure to rinse off any traces of gesso immediately after use. If the gesso is allowed to dry, the screen will be ruined.

This sample, shown left, was created using gesso with a thermofax screen. Due to the translucent nature of Lutradur, diluted paints or light washes of colour work best for this technique. If you wish for a colour with more depth then layer several pieces together or lay the Lutradur onto a dark background. Once dry, the piece was sprayed with diluted silk paints. In most cases the reverse can look as stunning as the front.

Gesso was used to print with a thermofax screen onto Lutradur 70. When dry, diluted silk paints were sprayed on the surface. The lower pic shows the reverse side.

## ROLLING

Using a brayer is another way to transfer the gesso to the Lutradur.

1   Pour some gesso onto a glass plate or a piece of acetate and load your roller. Transfer the gesso to the Lutradur by rolling over the surface.

2   Hold the roller just above the surface and use a really light touch as you move it along. If the roller is pushed down too hard, you will end up with big splodges of gesso. Roll in all directions but leave some of the Lutradur surface free of gesso so that, when colour is applied, there will be a change in tone.

3   With the gesso side uppermost, lightly spray diluted colours on the surface and leave to dry thoroughly.

TOP SIX: Gesso rolled onto Lutradur 100.

BOTTOM THREE: Samples of Lutradur 100 with a gesso resist sprayed using silk paints, Brusho watercolour powders and disperse dyes, all diluted to make quite a weak solution.

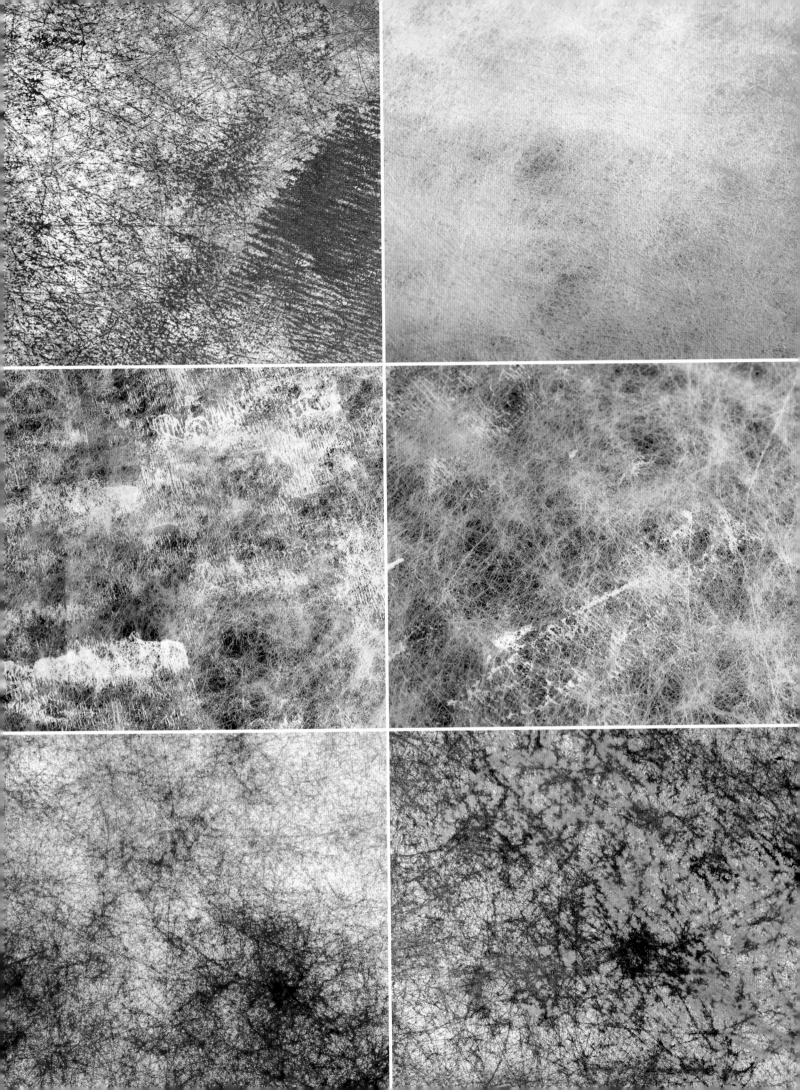

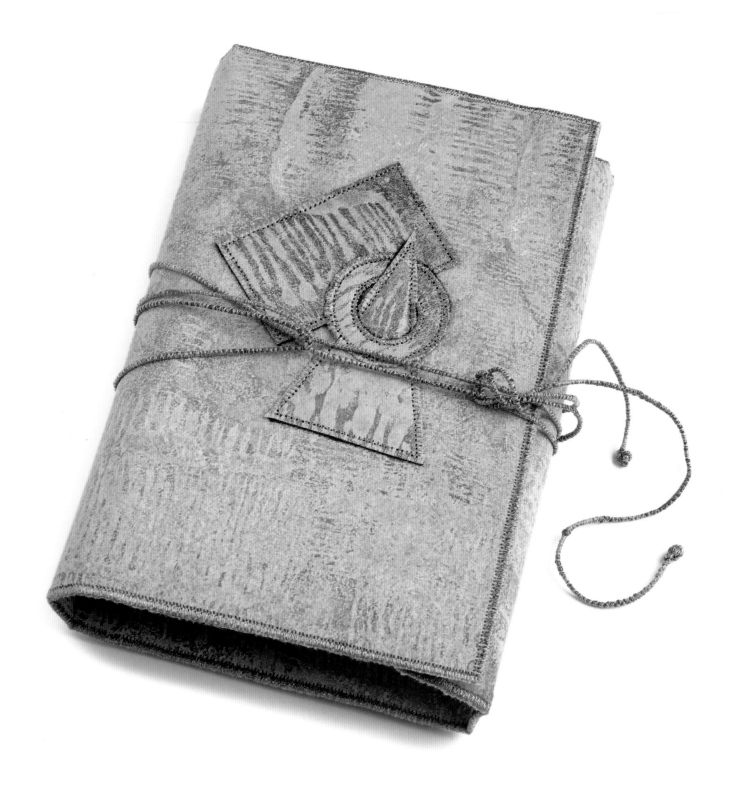

## FOILING

Foil can be added to the surface without the use of heat or adhesive by using a metal spoon. With the gesso side uppermost, lay the foil shiny side up on the surface and rub lightly with the side of the spoon.

This book wrap was created using Lutradur 70. Gesso was applied with a roller and diluted silk paints were then sprayed on. The surface was foiled lightly using the no-heat method. The lining is a piece of the same fabric but, this time, foil was adhered to the surface using a fusible webbing.

## BLACK LUTRADUR

Black Lutradur is only available in 70g weight. Use the same colouring agents and methods as above to achieve some really wonderful results.

Try letting the gesso dry and colour it with diluted silk paints. Then lightly foil with gold foil. This works well when placed on a black felt background with an automatic machine-stitch pattern worked in rows on the surface.

Automatic machine stitching with a gold thread produced a very dramatic surface on black Lutradur which was painted with gesso and silk paints before being burnished with foil.

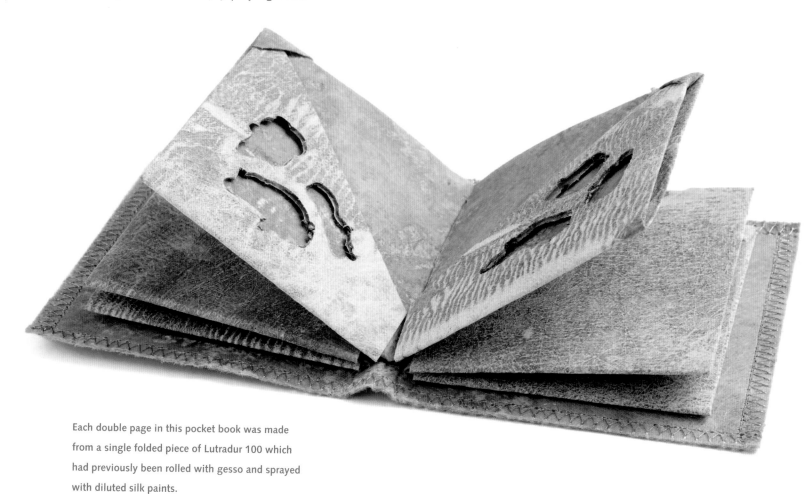

## MAKING A 'POCKET BOOK'

This folded pocket book was made using Lutradur 100 with gesso, diluted silk paints and foil. The book holds three signature pockets.

Sections of the pockets have been burned out using a fine-tipped soldering iron to enable you to peek at the contents slotted inside.

Don't be afraid to experiment with different materials and techniques; the outcome may surprise you and will make the piece of work uniquely your own. Above all, we hope you have enjoyed this insight into some of the techniques we both enjoy playing with.

Each double page in this pocket book was made from a single folded piece of Lutradur 100 which had previously been rolled with gesso and sprayed with diluted silk paints.

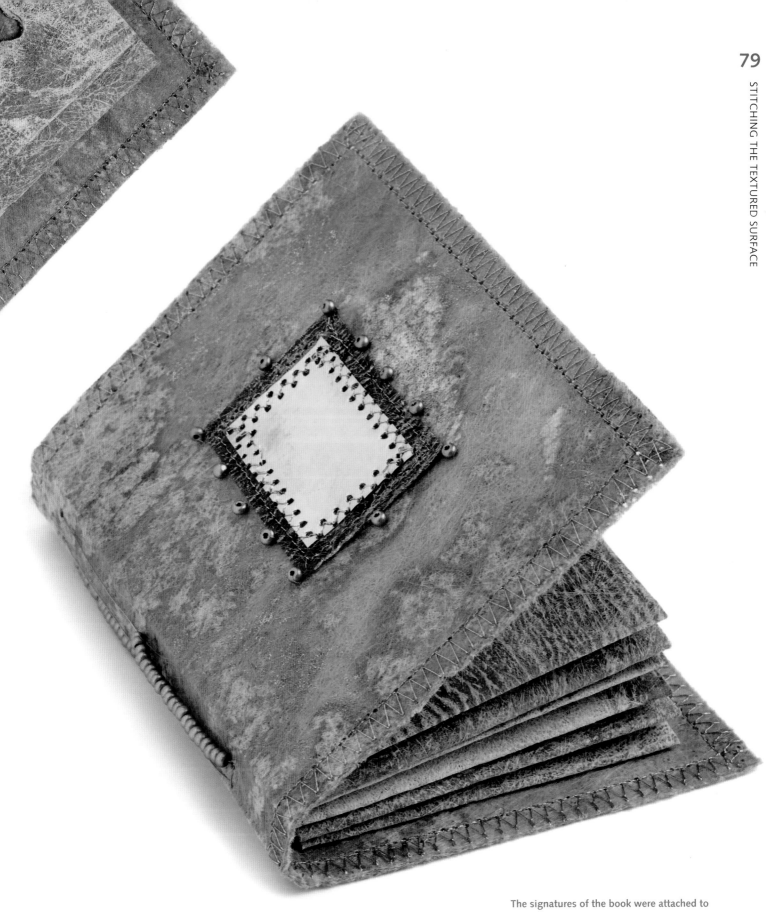

The signatures of the book were attached to the outer cover using pamphlet stitch, with a beaded wire to match the copper shim and beaded decoration on the front.

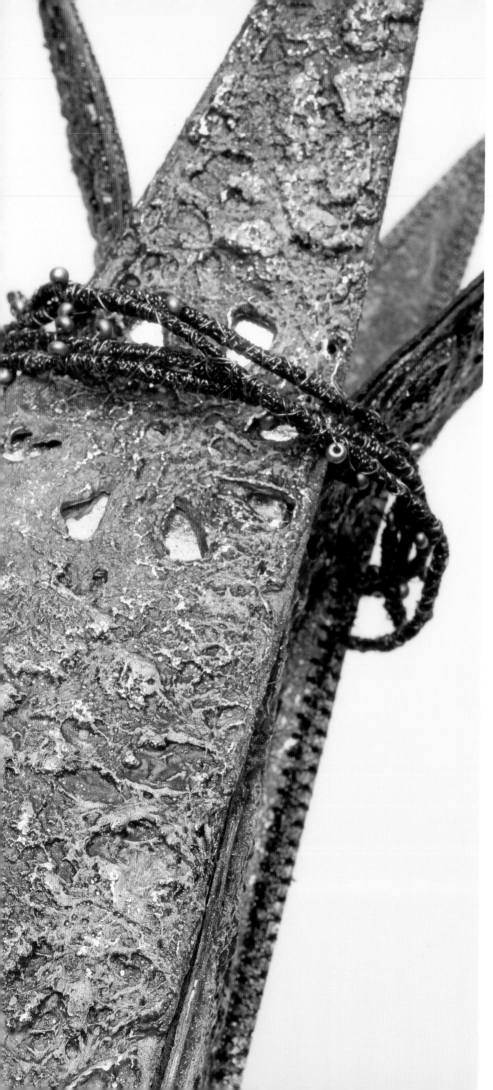

# Resources

## UK

**Ario**
*Gesso, Moon Shadow Mists, Tissutex,*
*Treasure Gold*
5 Pengry Road
Loughor
Swansea
SA4 6PH
fiona@ario.co.uk
www.ario.co.uk

**Art Van Go**
*Gesso, Pearlex Powders, scrim, calico,*
*Treasure Gold, Golden's molding paste,*
*acrylic paints, copper shim, metal leaf*
The Studios
1 Stevenage Road
Knebworth, Hertfordshire
SG3 6AN
art@artvango.co.uk
www.artvango.co.uk

**Crafty Notions**
*Creative Sprays, stencils*
Unit 2, Jessop Way
Newark, Nottinghamshire
NG24 2ER
enquiries@craftynotions.com
www.craftynotions.com

**Fibre in-Form**
*Foils*
Russell Court
6 Woodland Park
Colwyn Bay
LL29 7DS
info@fibreinform.com
www.fibreinform.com

**Nid-Noi**
*Lutradur, Evalon,*
*heavy pelmet Vilene*
126 Norwich Drive
Brighton
BN2 4LL
info@nid-noi.com
www.nid-noi.com